Kathy Peterson's
GREAT OUTDOOR
DECORATING
MAKEOVERS

Kathy Peterson's

NG MAKEOVERS

Easy, Elegant Transformations
on a Limited Budget

Watson-Guptill Publications

New York

First published in 2004 by Watson-Guptill Publications,
a division of VNU Business Media, Inc., 770 Broadway,
New York, NY 10003

Library of Congress Cataloging-in-Publication Data
Peterson, Kathy, 1956-
 Kathy Peterson's great outdoor decorating makeovers:
easy, elegant transformations on a limited budget /
Kathy Peterson.
 p. cm.
 Includes index.
 ISBN 0-8230-2612-4 (alk. paper)
 1. Outdoor living spaces—Decoration. I. Title: Great
outdoor decorating makeovers. II. Title.
 NK2117.O87P47 2004
 747—dc22

 2004001678

Senior Editor • Joy Aquilino
Editor • Holly Jennings
Designer • Alexandra Maldonado
Production Manager • Ellen Greene

Printed in China

First printing 2004

3 4 5 6 7 8 9/12 11 10 09 08 07 06 05

Typeface Avant Garde

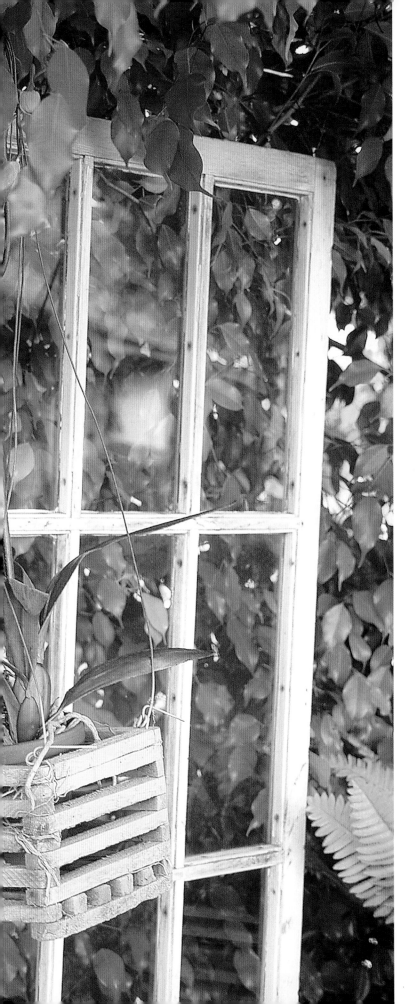

Thank you dear Lord for giving me all the talents I possess and letting me share my creative spirit with others. Because of your love, I am here to write this book.

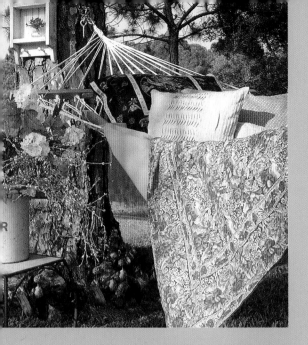

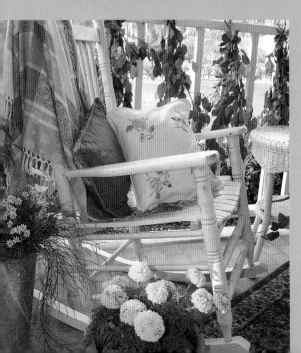

CONTENTS

INTRODUCTION

I love a challenge, and especially when it comes to design and decorating! In this book I invite you to follow along as I confront and solve an abundance of outdoor decorating problems with an "anything goes" attitude and a small $250 budget. For starters, I was faced with the painful challenge of redecorating my own outdoor spaces that had been dreadfully neglected due to my hectic work and travel schedule. Needless to say, I was almost too embarrassed to claim these spaces as my own in this book. But, as the saying goes, the painter's house never gets painted. So too, this designer's outdoor spaces didn't get decorated until the making of this book.

Though I have no formal training in design or decorating, I've found, through my own decorating dilemmas and design challenges, that I can transform most any space into a wonderful oasis. The real challenge is working within a $250 budget. And, yes, with a lot of imagination, creativity, and courage, it can be done.

To help you accomplish your own outdoor decorating goals, I've sprinkled practical and cost-cutting

designer tips throughout this book, including several down-and-dirty makeover ideas such as "Getting Crafty" and "From Common to Custom."

From years of experience, I have found that a creative use of color is one of the most important aspects of successful outdoor decorating on a budget. It can truly set the character of any outdoor space. Big, bold bursts of color can define a tabletop, wall, or floor surface. I've also found that even small accessories, such

Flower-filled pots and vases add individual bouquets of color and are no-fail decorating solutions.

as tableware, flea market finds, and potted plants, can
transform an ordinary outdoor space into a wonderful
oasis. Experimenting with combinations, for instance
mixing and matching your tableware or furniture, can
lead to delightful and whimsical outdoor settings.
Take advantage of the unique features in your out-
door space to create restful settings. Place chairs in
small groups near a birdbath, fountain, or pond. If

*Combinations of crystal and pottery
mixed with colorful napkins and
greenery can create a welcoming
table setting.*

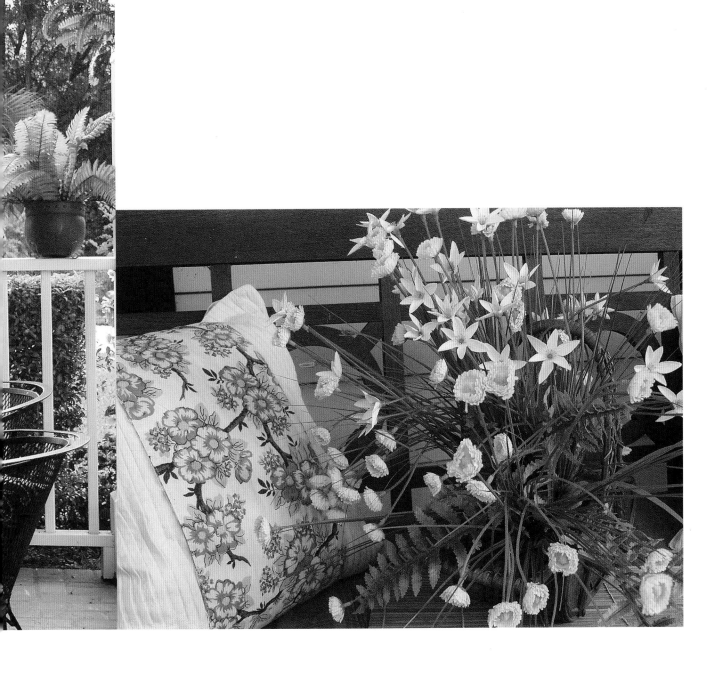

your porch or patio lacks points of interest, create more ambience by moving furniture from inside your home to the outside. Depending on the size and lay-out of your porch, patio, or deck, you may prefer to create several cozy groupings of furniture to suggest private conversation areas.

Anyone can do the makeovers I share with you in this book, and I encourage you to find your "designer

For an easy makeover, add some sparkle with an antique vase or liven up the space with a few flowers. The pillows pull the colors from the interior of the house to the outdoor space.

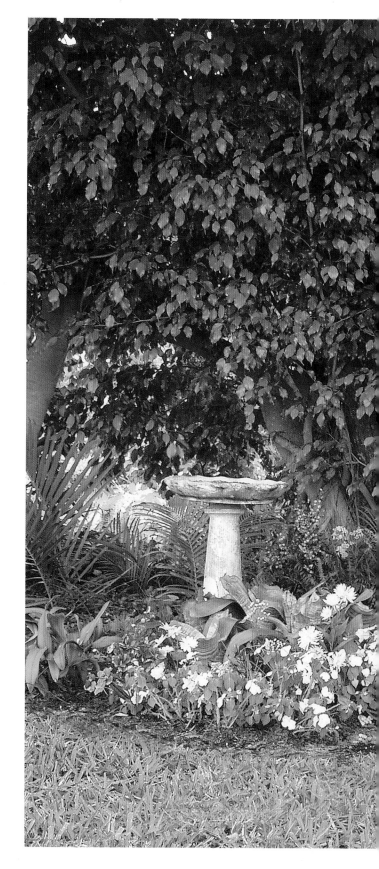

A birdbath, vintage window, and painted furniture surrounded by colorful flowers add ambience to this outdoor setting.

spirit" to create your own affordable outdoor makeover! One of the best ways to get started is to go on a treasure hunt in your own house. Short on patio furniture? Go back inside and gather chairs from the kitchen or dining room. Climb up into the attic or search your garage for buried treasures. And, whether you're handy or not, it's easy to construct an inexpensive table from a couple of sawhorses and an old door. So have fun discovering a wealth of decorating knowledge as I show you how to make your own outdoor space into a wonderful extension of your home by simply using color, creativity, and just a little bit of money!

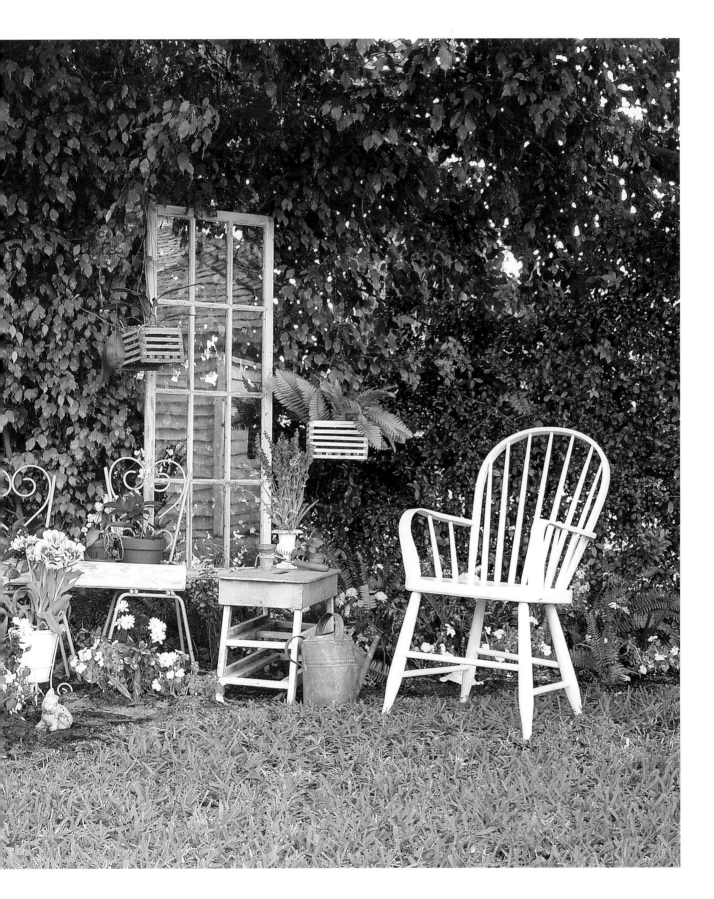

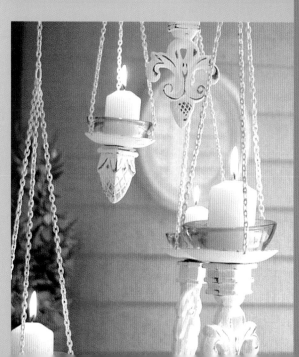

Part 1

GETTING READY

In this part of the book, you'll discover ways to find inspiration and learn basic decorating principles you can use when you're ready to move from inspiration to a real, honest-to-goodness makeover. If you're a beginner, then an outdoor space can be the perfect place to start. It's less challenging than decorating a room inside your home since in most cases there are no walls to paint. Often outdoor furnishings can be given a new look simply with a fresh coat of paint or by recovering cushions.

Finding Inspiration

Don't know where to start? Inspiration can come in many forms, and if you keep your eyes wide open, you might be surprised by what you find. Inspiration is often free if you simply know where to look. To start your outdoor makeover, begin with your own spare furniture, pots, fabrics, and found objects. It's easy to spruce up what you already own with a fresh coat of paint. But if you're not inspired by what you've got lying about your home, expand your inspiration horizon. For instance, you might get inspiration from a friend's porch or patio, historical home sites, open houses, furniture stores, books, magazines, and even paint brochures. Television soap operas and sitcoms are another great source of inspiration. The sets on television shows, which are decorated by leading stylists, will give you an idea of the latest colors, trends, and textures at a glance. And for inspiring bargain finds, excursions to flea markets, thrift stores, and garage sales can be a gold mine.

HITTING THE BOOKS

Still can't figure it out? Seek out inspiration from magazines and books such as this one to help guide your ideas. These readily available sources of information and inspiration will help you with color combinations and furniture placement. Start a clipping file of pictures from magazines and newspapers to stay focused and organized.

DESIGN EXCURSIONS

Tired of having your nose between two book pages? Take design excursions to get a look at decorating schemes in the flesh. Merchandizing displays located in department stores or other retail settings can be great sources for ideas about furniture arrangements, the use of color and accessories, and design trends. Visits to house museums will introduce you to different period styles. Going to open houses held by realtors or homeowners is a fun way to see how others have decorated their outdoor spaces, and, if spruced up for prospective buyers, open houses often display the newest trends in colors, furniture, and fabric. Private home tours sponsored for charity events or other occasions are also a great way to get wonderful decorating ideas and inspiration. If you are inspired by what you see during any of your excursions, chances are you can recreate what you've seen in your outdoor space for a fraction of the cost simply by being crafty and resourceful.

This flea market chair cost $5 and was left in its original condition. The stool is a $2 garage sale find. I painted it blue and white, inspired by my antique blue water pitcher. The pots and plants came from another part of the house; the pots were also painted blue and white.

Color

A creative use of color is one of the quickest ways to get dramatic makeover results in your outdoor living space. Where can you find inspiration for color? You might start with something you look at and use everyday—your wardrobe! For instance, think of colors and patterns that you would wear together. Would you wear brown plaid with purple polka dots? Probably not! So, would you decorate your porch with plaids and polka dots? Probably not. Say, for instance, you love to wear blue jeans and you would like to use blue somewhere on your porch, whether it be on your walls, cushions, or floor. Next, select a shirt that you would like to wear with your jeans. Is that the color or pattern you'd like to see on your porch? If so, your closet can offer you color inspirations and color courage. Remember that if you would wear it, you most likely can live with those colors in your outdoor space as well.

NATURAL BEAUTY

I love to go to nurseries and the garden departments of major retailers. Natural colors and textures abound, and are a great source of inspiration. For an interesting effect, select and combine plants of varying colors, heights, shapes, and textures. For example, when arranging plants, try combining plants of contrasting textures in groupings—such as large leaf with small, narrow leaf plants, solid leaf with variegated leafs, and flowers with cacti.

Placing bold colored plants in unusual settings will add interest to your outdoor space. Here I've used the seat of this Adirondack chair as a plant stand for a vibrant petunia.

∨ *You needn't use a conventional plant stand. Instead, think outside the box when displaying your plants. In this instance a candle stand was used. Chairs, buckets, and magazine racks can also make great plant stands.*

COMBINING COLORS

Choosing and combining colors is a fun and exciting challenge. But, if you're lacking color courage, it's best to keep it simple. This will give the appearance of a clean, well-thought-out space. But, above all, don't be afraid of color. By combining two or more colors, you cannot go wrong if you work with analogous pairs—that is, a primary color and an adjacent secondary color, for example, blue and purple or blue and green. Since green and purple both have some blue in them, they will always visually relate to blue. Remember that bold, saturated colors can send a strong color statement. Pastels, on the other hand, will create a soft mood. Before making your final color decision, you should always see how the paint chips and fabric swatches you're considering look in outdoor light.

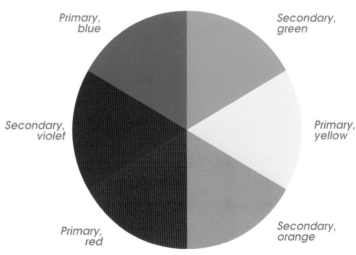

Primary, blue

Secondary, green

Primary, yellow

Secondary, orange

Primary, red

Secondary, violet

> *This color wheel shows the primary and secondary colors. Secondary colors are derived from mixing two primary colors. Colors that sit opposite each other on the wheel are complementary pairs.*

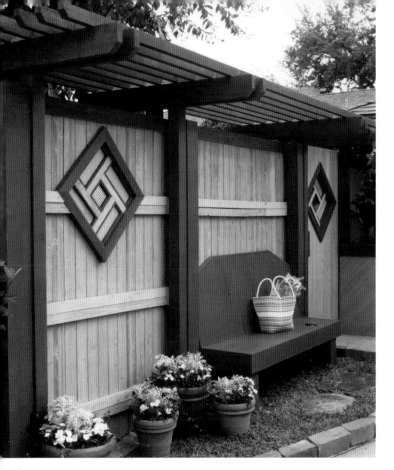

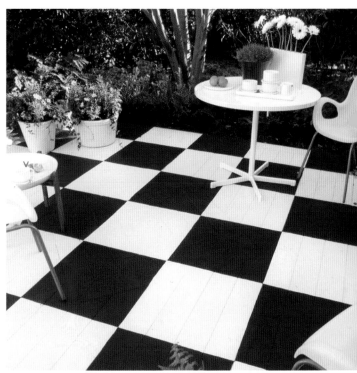

High Contrast, High Impact

Combining contrasting colors is a sure way to give your makeover a big, bold statement. Colors contrast with each other if one is light and the other dark. The greater the difference in lightness and darkness the greater the contrast, so naturally a pairing of black and white provides the greatest contrast of all. Deep, saturated colors such as brown, cobalt blue, and black placed against light walls and patio surfaces will create high contrast. If you feel as if your furniture is floating and is currently a light color, try painting your furniture dark and handsome colors to anchor it against lighter background surfaces.

In addition to combining light and dark colors, the use of complementary colors automatically provides contrast. Complementary colors sit opposite each other on the color wheel (see page 19). The complementary pairs are purple and yellow, blue and orange, and green and red. They are always pairs of one primary and one secondary color. When used in a color scheme, they will appear to optically vibrate or "pop." If high contrast is not your color preference, then think of decorating with a range of similar colors, whether you choose light colors, such as pastels, for a subtle effect,

∧ *(Top, left) The brick red and stone-colored stains used on this bench and pergola contrast handsomely with each other and provide a soothing color scheme. Note that even the combination of the grayish white color of the dusty miller plantings and the color of the terra-cotta pots echo the stone and burgundy color scheme used on the pergola and bench.*

(Top, right) Using light and dark colors together immediately provides contrast. Black and white, of course, provide the greatest contrast. In this example, a checkerboard pattern of blue- and white-colored stains creates a strong impact. The round tabletop complements the hard lines of the painted squares. A square or rectangular tabletop would have been a less interesting choice for this patio makeover.

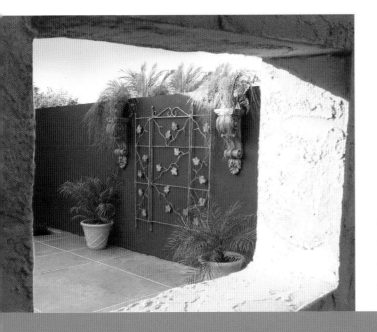

Bold, cobalt blue walls make a contrasting impact with this colorful terra-cotta floor. Blue and orange, being complementary, are naturally contrasting colors. Since both the cobalt blue and terra-cotta are saturated colors, the contrast and their impact are all the greater. If a pale blue and melon color were combined, their contrast, though still complementary, would not be as great.

or rich earth tones, such as brown, burgundy, or olive, for a deep, mellow effect. Your climate will also affect your color choice. Depending on your climate, you may need to consider using colors that hold up well under the glare of the sun. Ask your paint supplier what kinds and colors of paint and stains hold up best under your particular weather conditions or areas constantly exposed to sun.

WORKING WITH COLOR SCHEMES

There are endless ways to work with color. Sorting through the myriad of possibilities, let alone keeping up with current color trends, can be daunting. The questions in "What's Your Color Scheme?" are meant to get you started down your own path to an inspired outdoor makeover. As you will see, there is no particular right or wrong path to a successful color scheme. Ultimately, your most successful scheme will be one that reflects your personality. I've also included a sampling of themes and palettes to inspire you, but they are by no means exhaustive. The only limit to what's possible is your own creativity.

WHAT'S YOUR COLOR SCHEME?

- Are you inspired by a particular piece of furniture or accessory you'd like to use in your outdoor makeover? One fabulous piece can be a springboard for an entire outdoor color scheme.

- Are you in love with the colors inside your home? If so, carrying them outside, or using colors outside that complement those inside, is a natural color selection.

- Do you enjoy color combinations that are bold, that pop, and that are contrasty? If so, think about using dark and light colors together, as well as complementary colors, for example, orange and blue, red and green, or yellow and violet.

- Do you enjoy harmonious and tranquil color combinations? If so, use colors that are close to each other in intensity and hue.

For example, use cool colors such as green and blue with turquoise and purple. Remember that light shades are more tranquil, while vivid colors are more striking.

- Do you enjoy colors that are deep, dark, moody, strong, or earthy? Then use colors associated with fall, such as browns, burnt orange, or rusty red.

- Do you enjoy colors that are light, subtle, pretty, and delicate? Then use colors associated with spring, such as blue, yellow, and lavender. Often colors associated with spring are pastels.

- Would you like to convey an exotic style, such as Moroccan, Mediterranean, Turkish, etc.? Then use colors and patterns associated with these cultures.

Mediterranean Theme >

COBALT BLUE AND TERRA-COTTA

When most of us think of the Mediterranean, we think of vivid sunlight, relaxing breezes, and deep blue seas. The hallmarks of this style include a bold, cobalt blue color, textural terra-cotta tiles, fountains, tropical plants, and birds. This theme can create an exotic, almost vacation-like mood, and it's easy to maintain. This theme is more naturally suited to the southern states that have extended months of warm and sunny weather.

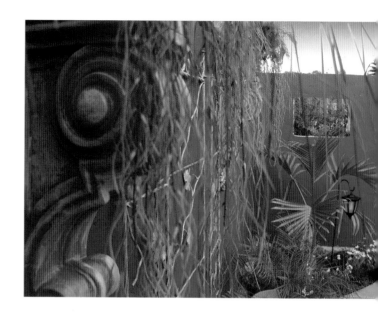

< Spring Garden Theme

ROSE, SOFT TEAL, APPLE GREEN, AND WHITE

Garden themes are an invitation to relax with Mother Nature. Tranquil pastel colors such as light greens, pink, and white can help evoke feelings of springtime sights and fragrances, and even create visions of fresh-picked flowers from the garden. This look is well suited for most any out-door space and lends itself to a more feminine look.

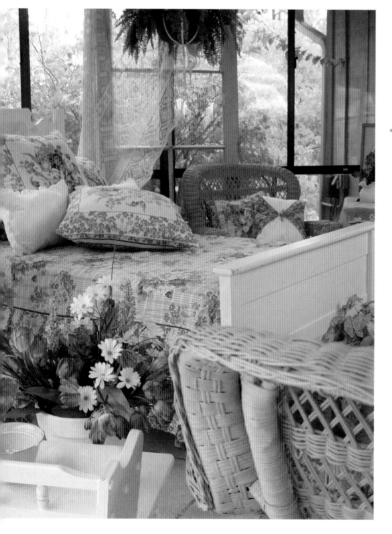

Asian Theme

RED, BLACK, AND LUSTROUS GOLD

Trademarks for an Asian theme are bold, rich colors from the Far East, such as red, black, and lustrous gold. Though this theme is not traditionally used for outdoor spaces, it can work wonderfully nonetheless.

Paris Café Theme

GOLDENROD, BERRY RED, AND APPLE GREEN

Parisians love to dine outdoors at the many sidewalk cafés that abound in their famous city of light and love. By using casual bistro furniture and colors reminiscent of a Paris café, such as goldenrod, berry red, and apple green, you can take a trip around the world without leaving your backyard.

Cape Cod Theme

AQUA, TURQUOISE, BLUE, AND SANDY BEIGE

When Cape Cod comes to my mind, I think of reflections of the ocean, sky, and sand. Using shades of turquoise, aqua, blue, and sandy beige will help evoke this famous light-filled vacation destination, bringing the beach to your very own backyard deck or patio.

French Country Theme

BLUEBERRY, WARM YELLOW, SOFT WHITE

For a soothing yet sophisticated outdoor theme, country French will complement your porch or patio when you combine blueberry, warm yellow, and a hint of soft white. This clean and stylish look is timeless and very pleasing to the eye.

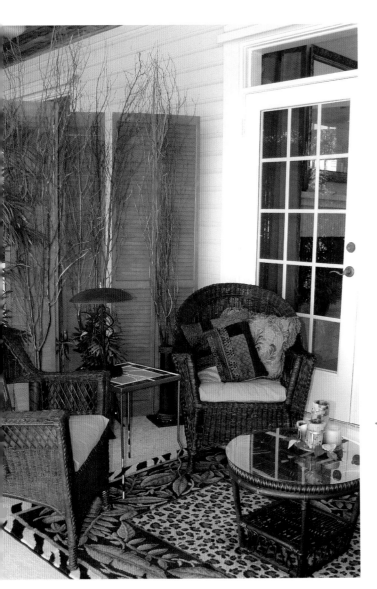

‹Jungle Safari Theme

DARK BROWN, KHAKI, PAPRIKA, AND OLIVE GREEN

Inspired by natural colors and animal prints from the jungle and plains, this theme is a wonderful decor for lovers of animals and exotic locales. Dark furniture, bamboo accents, and rich colors in brown, khaki, gold, olive green, and burgundy will surely evoke the Kenyan plains or African Congo in your imagination. This look is well suited to almost any outdoor space and has a more masculine design appeal.

Outdoor Decorating Basics

Have you dreamed of creating an outdoor oasis of your own but have felt unsure about how to make the best decorating decisions for your outdoor space? This section will give you several basic decorating tips to get you started on the road to decorating success. The ultimate tip, however, is to select a color scheme and decorating style that pleases *you*. Doing so will ensure that you'll enjoy your outdoor makeover for years to come.

CLEAR THE DECKS

Is your furniture in good shape but cluttered with too much *stuff*? Simply remove the clutter and odds and ends. This will help you see your space more clearly and visualize your new makeover. Your color selection will be less confusing when you've "cleared the decks," or even just removed table clutter. Also, does your outdoor space need to be cleaned or protected, or both? If so, take this opportunity to get it done before you begin your makeover.

Improve Circulation

Good circulation is a critical part of any successful makeover. Now that you've "cleared the decks," you can more easily consider the function and flow of your space. How will the space be used? And what will be the practical use of each piece of furniture? Will

To clear your decorating palette, remove furniture and tabletop clutter. This is one of the first steps in an outdoor makeover.

the existing furniture work in the space requirements? Do you and your guests navigate and use the space with ease? Will the furniture be a permanent fixture, or should you think about lightweight furniture for flexibility and easy movement? Thinking through these questions and experimenting with different furniture arrangements will help you arrive at the best possible circulation.

If you are using furniture that is too large for your space, make sure you can easily move it to accommodate greater circulation when entertaining. Consider using benches, tables, and comfortable chairs for conversation areas. For dining areas, experiment with lighting for ambience and select the best placement for easy access from the kitchen. For relaxation or reading, consider using a chaise lounge or plush chair with an ottoman. If your outdoor space is vulnerable to winds, select heavier furniture to prevent loss and possible damage to your or other's property. Lightweight furniture is best used in well-protected areas or for temporary use. Avoid too much furniture clutter or overcrowding, especially when your outdoor space needs a natural walkway from one end to the other.

These traditional red-and-white linens, found inside the home owner's linen closet, offer lots of color for any special outdoor occasion.

BRING THE INDOORS OUT

If your outdoor space is an extension of your interior, or if your outdoor space can be seen from your interior, consider using colors that match or complement your interior. But even if your outdoor living area isn't connected to your home, think about carrying the color theme from within your home to the outside. Colors

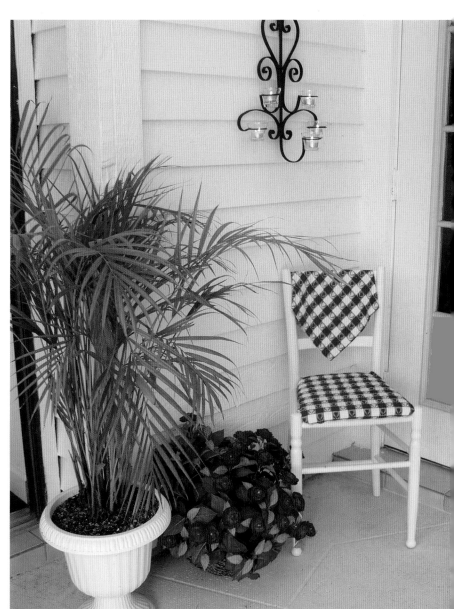

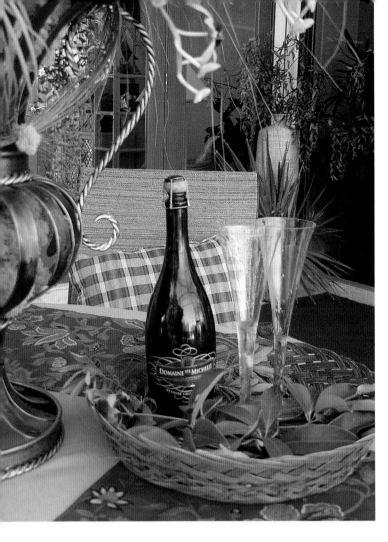

On this patio, pillows and table accessories from inside the owner's home help to create an elegant outdoor retreat.

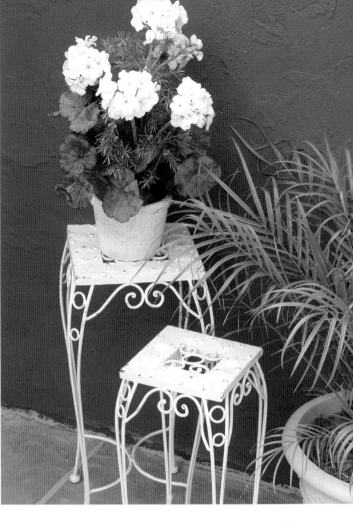

Decorative metal plant stands from inside the owner's home create color contrast against this deep, cobalt blue wall.

from interior accessories such as pillows, uphol-stery, and wall coverings are a natural and ready source of inspiration for your exterior space. But when you're decorating for a spe-cial occasion, it's always fun to use colors that complement the occasion.

ENHANCE WITH ACCESSORIES

Adding pillows, chair cushions, different chairs, and a new tablecloth are easy do-it-yourself projects. These simple ideas add color, comfort, and class. Even simple things such as adding ironwork, candle sconces, or shiny new brass kick plates and doorknobs to exterior doors can make a noticeable difference.

SOME FAVORITE ACCESSORIES

- Tablecloths (preferably cloth)
- Candles (votive, pillar, or taper)
- Runners, doilies (new or antique)
- Napkins (preferably cloth)
- Spare furniture (culled from your attic, garage, basement, or overly cluttered rooms)
- Houseplants (before purchasing, ask a garden-ing expert about the right plants for your climate and light conditions)

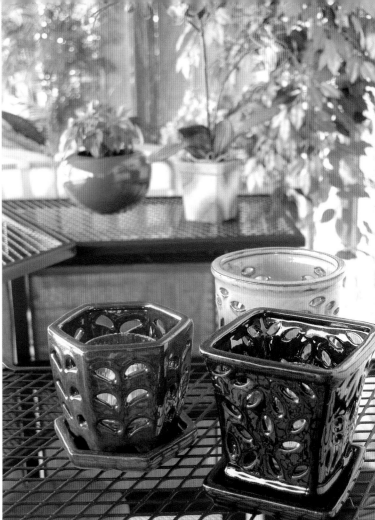

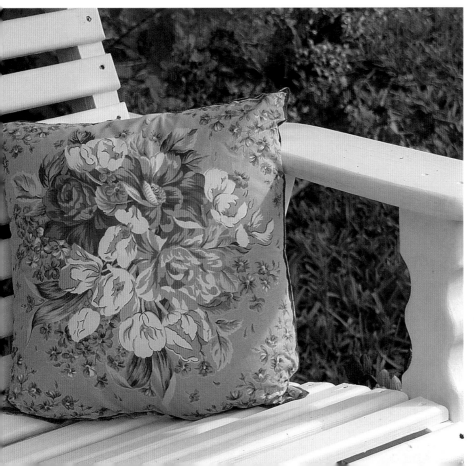

∧ (Top, left) Add cheerful color accents with cushions, plants, and chairs from other parts of your home.

(Top, right) Candleholders are great decorative accents for any outdoor space. These candleholders were originally orchid pots!

< The pretty floral fabric on this pillow complements the nearby flowers.

CREATE MOOD WITH LIGHTING

During the evening, rather than blast your outdoor space with bright lights, think about using candles to create a soft, shadowy lighting effect. For a bold and dramatic effect, place a focused spotlight behind a sculpture, a tall plant, or any centerpiece of visual interest. Outdoor lighting fixtures that are both decorative and functional are always a great enhancement to any decor.

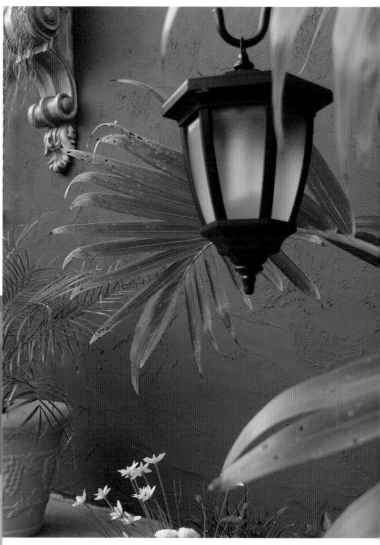

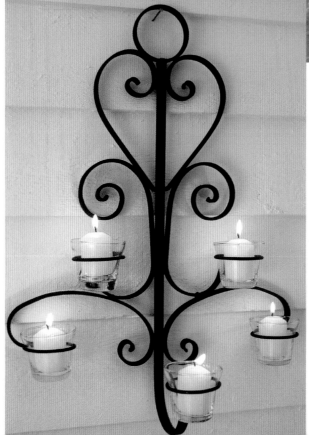

^ Candle lanterns provide mood and light, and are a good option for outdoor spaces where electricity is not available.

< Candle sconces create mood with lighting and help to decorate blank exterior walls.

> Hung from the porch ceiling, these finial candleholders create a decorative backdrop against the porch screen.

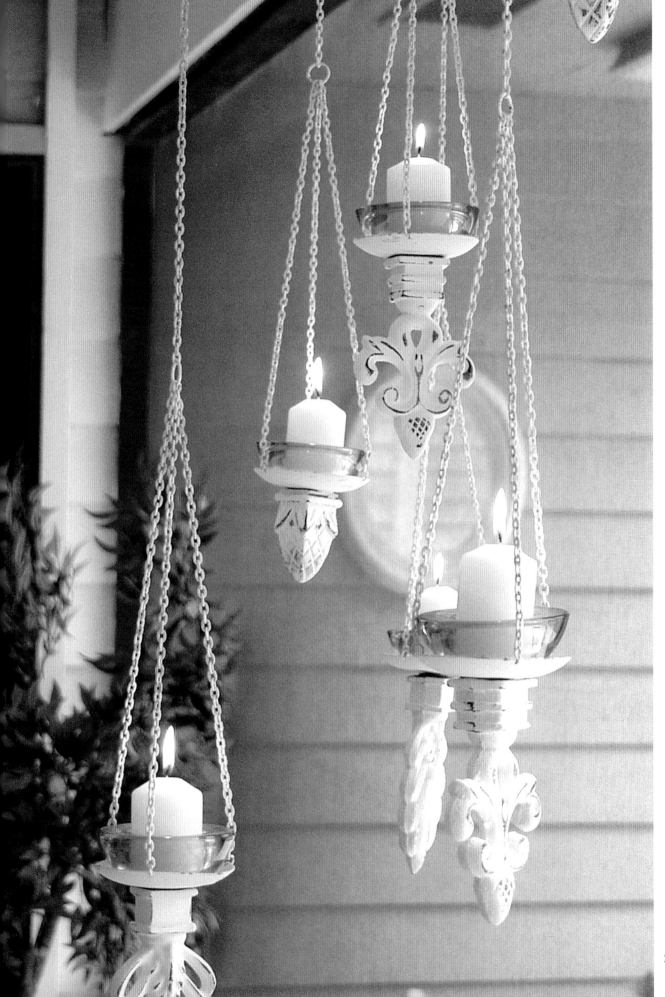

SOFTEN EDGES WITH FOLIAGE

Foliage can be used to soften hard surfaces and edges in your outdoor space. Often times, plants you already have in your yard can be separated into more than one plant and repotted. This is a great way to save money and liven up any outdoor space. For enclosed areas, consider using plants that don't shed their leaves or blossoms. To give your deck or patio a splash of color and texture, and give it a gardenlike appearance, use plants with a variety of leaf shapes and colors, or use blooming plants with pretty flowers.

MAKING THE RIGHT CHOICE

When shopping for plants you intend to place in a pot, always ask an expert if a plant is suited for potting. If you don't like the upkeep of live plants, consider using artificial trees and flowers in protected areas. But do not leave artificial greenery in direct sunlight. It is likely to fade and turn an odd shade of blue!

∧ I placed this potted plant on a vintage crate to create a casual, eclectic look and to soften the edges of the crate.

< A cheery yellow pot and flowers add brightness to the warm wood tones on this multistained deck.

MIX & MATCH: BLENDING STYLES

If your goal is to transform your patio, porch, or deck into an exterior room of your home, comfortable and practical furnishings are a natural choice. Of course, along with comfort and practicality, a makeover with style will give your outdoor space its unique character. Timeless design features such as wicker, wrought iron, and teak will last longer than furniture intended specifically for indoor use and will blend with most any decor.

But who says your furniture has to match? A mix of styles and materials can be very inviting and much more interesting than a perfectly matched decor. For example, a mix of styles might include a wicker chaise lounge nestled next to a small wrought-iron side table, or pretty handpainted pots resting near canvas cushions on a wood deck. Use your imagination to reflect your own sense of style and don't be afraid to mix it up a little.

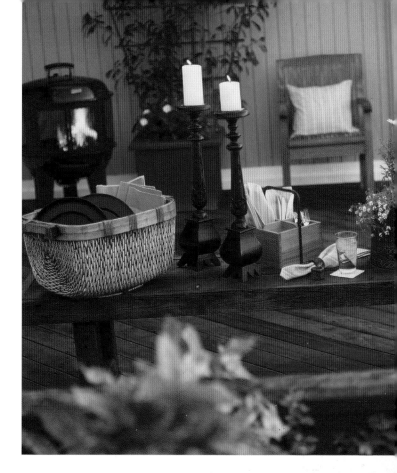

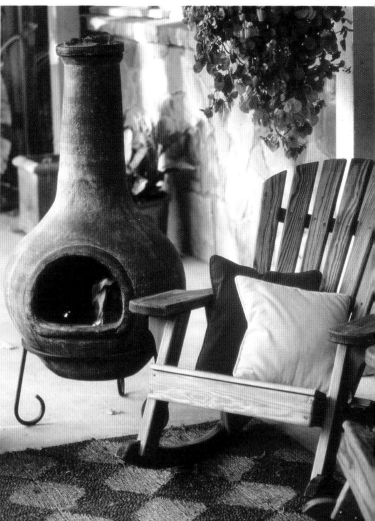

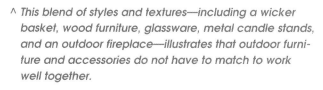

∧ *This blend of styles and textures—including a wicker basket, wood furniture, glassware, metal candle stands, and an outdoor fireplace—illustrates that outdoor furniture and accessories do not have to match to work well together.*

> *Here a variety of outdoor furniture and accessories—a wood chair, ceramic chiminea, checkered rug, and handsome cushions—have been combined to create an interesting style mix.*

MIX & MATCH: BLENDING COLORS

If you mix and match colors, your outdoor space will look more relaxed and lived in, and will encourage your guests to linger longer. To help you visualize how color works, envision a white room in which everything, including the walls, floor, and all the furnishings, is painted white. Obviously this would be boring and oppressive. If you add even one extra color, the room suddenly becomes more interesting. The more colors you add, the more interesting and lively it becomes. Of course there is a danger to adding too many colors—the room will become too busy, confusing, and chaotic. Think back to your wardrobe. Would you wear brown plaid with purple polka dots? Add too many colors and patterns to your outfit and suddenly you're dressed like a clown. The same goes for your outdoor spaces.

TIPS FOR RENTERS

If you're a renter, don't despair! With simple decorating cover-up ideas for your floor or walls, you can add pizzazz to your outdoor space. Let's say your landlord won't let you paint the walls or floors of your outdoor space. Ah, ha! Use rugs to cover a floor or wall, room dividers and matchstick blinds to add privacy, or large pieces of art to hide stains on a wall. Or, if you're feeling crafty, try painting an artist's canvas and attaching it to a wall. When you're ready to move, simply take it all with you for your next outdoor makeover.

∧ *(Top) The blue stain on this casual wood furniture echos the cool bluish color of the elegant, stone archway and helps to link the two contrasting textures and styles, creating a harmonious yet interesting outdoor color combination.*

(Bottom) Candles in contrasting colors can help blend and offset color. Here a burgundy candle complements and adds a splash of color to the brown and green accents.

> *Can't paint your floors or walls? Then think about using fabric and canvas. Here a fabric room divider adds color and charm to this cozy outdoor retreat and a handpainted floorcloth helps define the space.*

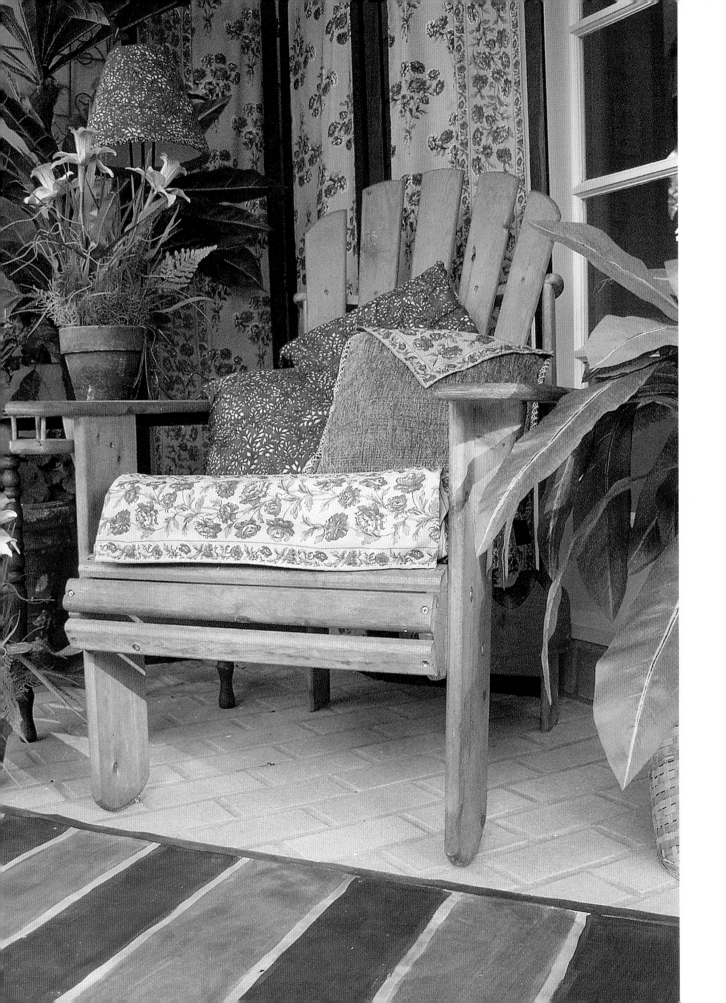

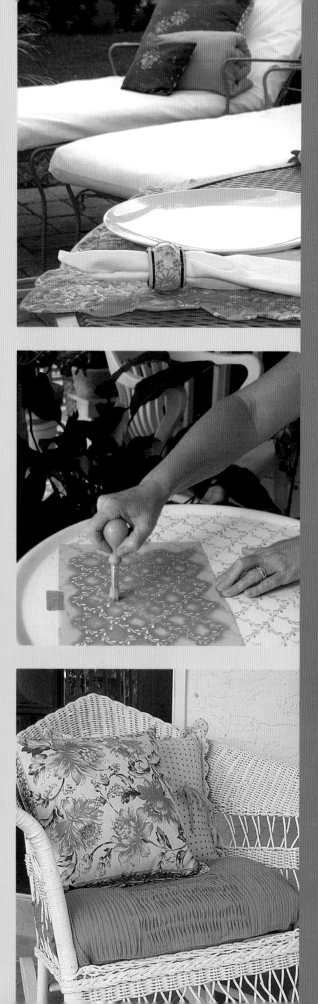

Part 2

GETTING DOWN TO BUSINESS

If you think it's nearly impossible to work within a $250 budget, guess again. The inspiration came from a feature article on before-and-after porch makeovers that was written for my local newspaper. Little did I know when I agree to participate in the project that the challenge was to work with a $250 budget provided by the newspaper. After getting over the initial shock of the small budget, I gathered my thoughts, and my creative ideas began to flow. In this part of the book, I will share with you several suggestions on how to "get down to business," including getting organized, searching for treasures, and putting your plan into action—all on a remarkably small budget of $250.

Developing a Plan

Your plan of action should be based on the colors, furniture styles, and accessories you wish to use in your outdoor space. Having a clear plan of action will help you stay focused on your goals. Remember to keep tabs on your $250 budget, and don't be tempted to purchase ready-made items.

STAYING ORGANIZED

Professional designers start every new decorating project by gathering and assembling samples of colors, textures, fabrics, and finishes. You should do the same. I can't stress this point enough, especially for the beginner who just can't quite "see" the whole makeover on a $250 budget. Keep a file or notebook to store clippings, paint chips, and fabric swatches for reference and inspiration. Make a shopping list and take a calculator with you when you go shopping to help you stay on budget. When shopping, trading, or even trash picking, carry a tape measure with you to make sure you don't bring home accessories or furniture that are too big for your space.

A simple and inexpensive way to spruce up your outdoor space is to add a colorful tablecloth or chair cushion to your furniture. This will make your outdoor space feel homey and won't cost a fortune.

The Search Is On

Unlike their pampered indoor equivalents, furniture, fabrics, or carpets destined for outdoor use must contend with Mother Nature. When choosing items for outdoor use, ask yourself if they can withstand heavy wear and tear from cold, heat, rain, wind, and mildew. Using furniture that will likely be damaged if exposed to weather for prolonged periods of time can be a costly mistake. The best choices are weather-resistant furniture, fabrics, and canvases. Fabric for cushions and pillows can be used in well-protected outdoor spaces but should be sprayed with a waterproof protectant. However, vinyl or acrylic fabrics that dry quickly and are mildew resistant and fabrics that can be removed for cleaning are always the best bets.

< Pillows exposed to the elements should be used only temporarily, or treated with a water-repellent product.

USE WHAT YOU HAVE

Start with what you already own. Ask yourself if existing furniture on your porch or patio can be painted, stained, or refinished for a more stylish look. Search out fabric remnants, tablecloths, and furniture you may have stored away years ago. With a bit of custom touch-up work, gently used or forgotten items can be pieced together to create a very pretty outdoor space. By using crafty tactics you will be able to redecorate your outdoor space with flair and stay within your budget.

Simple ideas such as bringing accessories or furniture from the inside out can make for a cozy transformation. If you have a covered porch, and it is well protected from weather elements, it's okay to use objects—such as candles, mirrors, upholstered furniture, and rugs—that normally are used in interior spaces.

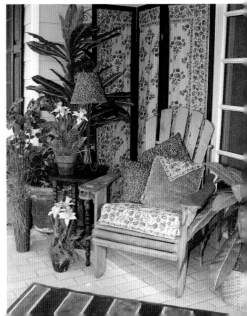

> These before-and-after photos show how pillows, a cushion cover, and panels for a room divider—all made from a cut-up tablecloth the home owner had on hand—helped create a colorful, yet simple, corner makeover.

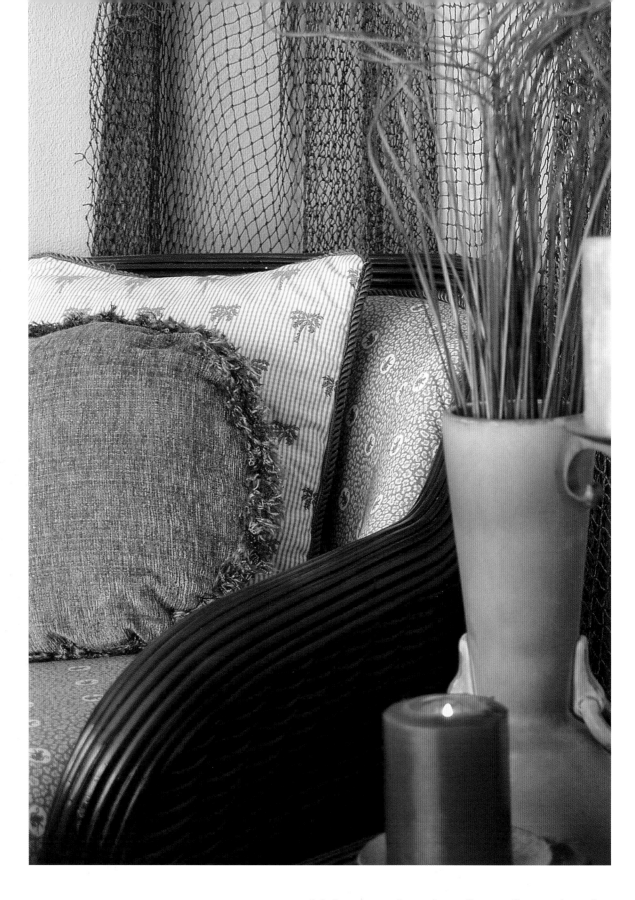

Interior accessories such as pillows, pottery, and candles work well if placed in a well-protected outdoor setting.

HUNTING AND TRADING FOR TREASURES

Are you a treasure seeker? Even if you're not, try shopping at flea markets, garage sales, auctions, and thrift stores. These are always good sources for great finds at affordable prices. For the especially resourceful, treasures can even be free. Don't be too proud to pick through your neighbor's trash heap. I admit it—I've scrounged through my neighbor's cast-offs! Trading pieces may be an option too. Perhaps you have a friend or neighbor who has been eyeballing something you own. Try bartering with him or her for an outdoor piece you think he or she would be willing to swap out.

∧ *This attractive wicker table was found in the garbage in the home owner's very own neighborhood. This castoff was quite a find since it was in great condition and required no fixing up.*

> *These vintage iron chairs, which were discovered at a yard sale for only $7 each, have been given new life with a fresh coat of spray paint. Metal furniture is suitable in most any outdoor setting, heavy enough to stay put in windy conditions, and, if kept clean and painted with a rust-resistant paint, will last a lifetime.*

CARPET SECONDS AND REMNANTS

If you want to carpet your space, visit your favorite home improvement store just before the weekend. By visiting stores on a Thursday or Friday, you'll beat the surge of weekend warriors, and you'll have a better chance of finding carpet remnants. Though the yardage and colors may be limited, this is a great way to save money. Carpet remnants can sometimes be found at the end of a roll and are sometimes discounted in price by about 20 percent to 40 percent. Frequently markdowns will not be posted, so simply ask the store manager if you can get a better deal if the roll is near its end.

Outdoor carpet is the best bet for covering an entire covered porch. Smaller rugs are good choices for adding color and texture to a sitting area or high-traffic areas. When using carpets for exterior spaces, select fade-resistant polyester rugs or sisal rugs. Sisal is a strong and durable natural fiber that holds up well if kept dry and free of mildew.

MAKING THE RIGHT CHOICE

Always be sure to choose a rug that is durable enough for outdoor living. Sisal rugs and outdoor carpet are your best choices for durability. Use your own discretion when using rugs made for interior spaces, and use them in areas that are well protected from the elements of weather. If left outside, rugs meant for interior use will most likely soak up and hold water like a sponge, and deteriorate quickly.

This red polyester throw rug is recommended for interior use. Since this porch is not completely covered, this type of rug should be used for entertaining purposes only and not be left outdoors indefinitely.

Essential Makeover Tool Kit

Using the right tools always makes outdoor decorating projects more enjoyable and professional looking. Before you begin to tackle your great outdoor decorating makeover, gather the basic tools and supplies you will need for your project. The "basic tools" are indispensable for most projects. The list of "frequently used makeover supplies" is just that. These are supplies that I use frequently throughout the book, but not necessarily for every project. Depending upon the needs of your makeover project, your supply list may be shorter or longer.

THE BASIC TOOLS

- ☐ Hammer
- ☐ Paintbrushes and rollers (various sizes and naps)
- ☐ Paint trays and liners
- ☐ Saw and sawhorse (electric handsaws)
- ☐ Scissors
- ☐ Screwdrivers (Phillips and flat heads in various sizes, or electric screwdrivers)
- ☐ Sewing machine
- ☐ Shovel and smaller garden hand tools

FREQUENTLY USED MAKEOVER SUPPLIES

- ☐ Candles
- ☐ Craft paints (small bottles of acrylic paint in a variety of colors)
- ☐ Fabrics, towels, trims
- ☐ Gloves (gardening and latex)
- ☐ Latex paint (interior or exterior with low- to high-gloss sheens)
- ☐ Nails, screws, eye hooks, cup hooks
- ☐ Oil-base paint (if surface will be exposed to hard weather conditions, or if you're painting over an existing layer of oil-base paint)
- ☐ Paint brushes and artist's brushes (various sizes, including flat, round, and liner brushes)

- ☐ Painter's canvas or banner cloth
- ☐ Paint thinners, paint removers (if using oil-base paints)
- ☐ Pillow forms or Polyfil®
- ☐ Plant food
- ☐ Plastic bags (for keeping paintbrushes moist during short breaks)
- ☐ Sandpaper, tack cloth, steel wool
- ☐ Scrap wood
- ☐ Sewing supplies
- ☐ Sponges, rags, old sheets, and tarps (for cleanup and surface protection)

- ☐ Spray paint (for various surface applications such as metal, plastic, etc.)
- ☐ Spray paint gun handle (to relieve hand fatigue)
- ☐ Stepladder
- ☐ Tape measure, ruler
- ☐ Various containers, pots (for planting flowers and plants)
- ☐ Watering can
- ☐ Water-repellent products such as Craftgard®'s fabric protectant or Thompson®'s Water Seal® Sports Seal®, Leather and Fabric Protector

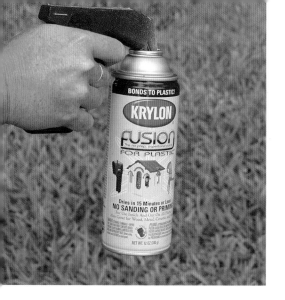

If you plan to spray paint accessories or furniture, use a spray can handle to relieve hand fatigue. This handy device simply snaps over the nozzle or cap of any spray can.

Low-Cost Makeover Ideas

By now you probably have a clear vision of your new outdoor living space. Most likely you have selected your colors and decorating scheme. But how do you create your vision for $250 or less? Simply by being creative and resourceful. This section gives you several money-saving decorating ideas that you can apply to your own projects—from transforming something common into a custom jewel to creating your own accessories from scratch.

SAFETY SAVVY

If you are cutting wood, sanding, hammering, or even painting, eye safety is always a concern. Wear safety glasses to protect your eyes, a face mask to protect your lungs from harmful fumes, and gloves to protect your hands from chemicals, splinters, and cuts. Never lift heavy objects incorrectly. If the job is too big for one person, ask a friend to help. When spray painting, work in a well-ventilated work space. If you are using spray paint outside, make sure the wind conditions are calm. Always work on dry surfaces and protect your work area with an old sheet or tarp.

IDEAS FOR FLOORS

Quick Coat: Painting Floors

Tired of that ugly concrete floor on your patio? Paint it! But be sure to follow all the paint manufacturer's instructions to ensure that your painted floor design has a long life. Always thoroughly remove dirt and debris from the floor before applying paint, and work in a warm/dry season if possible. This is good advice when staining wooden deck floors.

Getting Crafty: Floor Decor

You can create a decorative and handsome floor using your imagination, not your pocket book. For example, you can create the look of real tile using only a few dollars' worth of paint. If you're unsure you want to tackle an entire floor, start by creating a border using stencils or rubber stamps. Other little changes and simple accents, such as painted pots and painted accessories or surfaces, can make a big impact.

∧ *Before the faux tiles were painted on this concrete floor, the surface was swept, vacuumed, and washed.*

< *This concrete courtyard floor was handpainted to look like terra-cotta tiles.*

From Common to Custom

Painting a floor to look like stone or tile is a relatively easy way to customize your outdoor floor. Stenciling borders or geometric shapes is a great way to create a custom look and a focal point. If you're artistic with a paintbrush, think about using paint or stain to accent your floor with multiple colors. Alternating colors can create a sense of lively motion or of visual separation. Also consider making your own rugs from artist's canvas.

∧ Make your own custom canvas rugs by painting, stenciling, or rubber stamping a floorcloth. Floorcloth is a sturdy, heavy-duty artist's canvas made for floor decor.

> This deck has been creatively stained in alternating colors to create interest and evoke motion with the playful pinwheel design.

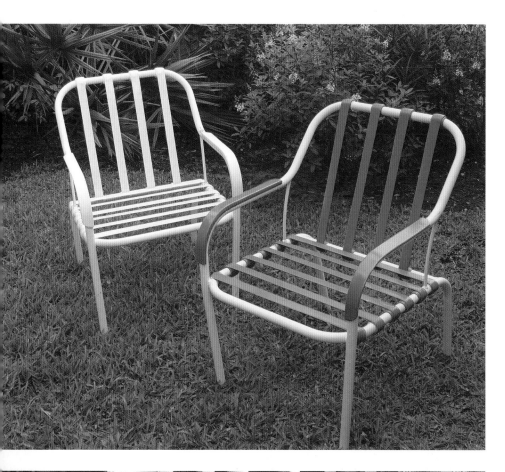

IDEAS FOR FURNITURE AND ACCESSORIES

Quick Coat: Painting Furniture and Accessories

One of the most noticeable differences you can make in your outdoor space is to paint something a bold new color. It will give your old furniture a much needed face-lift and protect it from the elements, thus prolonging its life for years to come.

Spray painting furniture and accessories, such as pots, is probably the fastest way to create a new look.

Handpainting can also be fun and easy but may require more drying time, thus extending the time to complete the project. Hit store sales too. Just because a piece of furniture may be the right price but isn't the right color doesn't mean it won't work. Simply paint it.

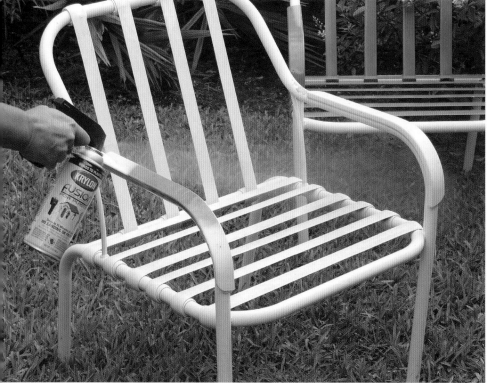

^ At the left is an ordinary and drab patio chair. Using Krylon®'s Fusion Paint for Plastic, a new color has been applied to the plastic strapping on the chair to the right, giving it a custom look.

< For best spray-painting results, always do a test spray first. Follow with an even, sweeping motion, maintaining a constant distance of approximately eight to twelve inches. Always apply spray paint in thin coats to avoid drips or runs.

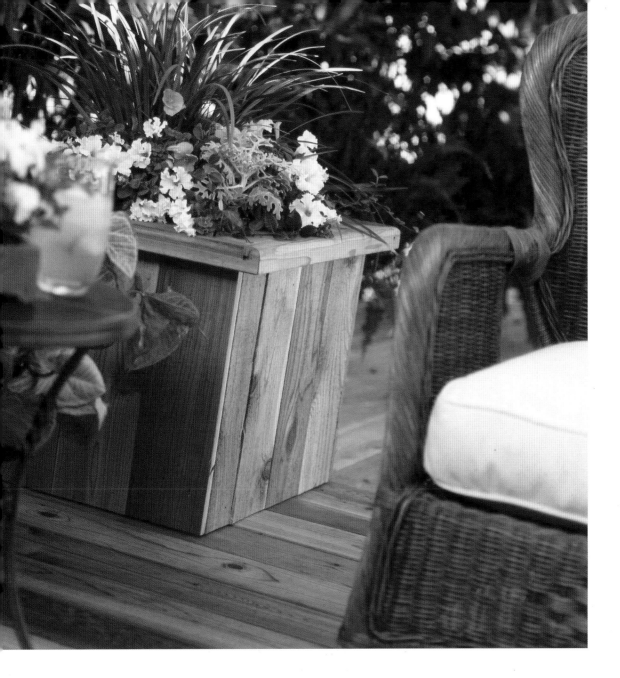

Getting Crafty: Build Your Own

If you or a friend is handy with power tools, consider making your own furniture or planters. Tools can be rented if you don't own them or can't borrow what you need. Project instructions are available in books and magazines. If you're a beginner, start with something simple, such as a planter box or shelf. Other alternatives are to buy kits that need assembly only or to hire a handyman to build the project for you. Most lumber supply outlets will cut wood to size for your project if you ask. This will help save you time and effort, but be sure to measure twice in advance.

With the right tools and supplies, building a planter box for plants, such as the simple one shown here, can be easy.

From Common to Custom

If you own plastic furniture, use appropriate paint products to give your furniture a custom look. By using Krylon's Fusion Paint for Plastic, a fresh, new, custom look can be created for a fraction of the cost of purchasing new chairs! To add more impact, combine more than one color on your furniture or add decorative touches using stains, stencils, or stamps. Check to make sure you're using the correct paint for each surface—such as plastic, metal, or wood—so that it bonds correctly. To prepare surfaces, check the product manufacturer's instructions.

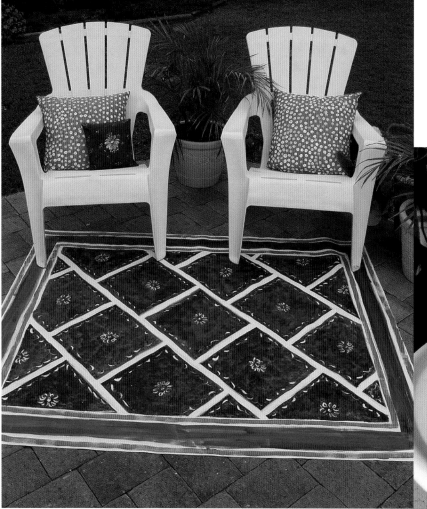

< *These plastic deck chairs were originally green and very faded.*

v *With a stencil brush and acrylic craft paints, you can add colorful stencils to any surface to create a designer look.*

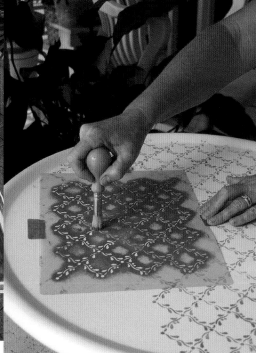

IDEAS FOR FABRIC
Double Duty: Reversible Decorating

Using fabric in creative ways—such as mixing textures, colors, and patterns—can help give your outdoor makeover a designer look. Here is a tip: If you purchase or make your own pillows, slipcovers, or cushions, choose items or fabrics that offer different colors or patterns on opposite sides. This will give you more decorating options.

DESIGNER TIP

If possible, store cushions in a well-protected area when they aren't being used. Create compartments for your outdoor cushions by using a chest or trunk with a cushioned top. This piece of furniture will serve double duty for storage and seating.

With a different color and texture on its front and back, this pillow is a versatile decorating accessory.

Getting Crafty: Easy Sewing Projects

If you're handy with a sewing machine—or even if you're not—easy-to-make slipcovers, coordinating linens, and cushion covers can be sewn for added softness and comfort, and can make ordinary furniture look more upscale. Begin by measuring the cushion, pillow, or chair you wish to recover, then cut and sew two squares or rectangles of fabric together for a fast and easy sewing project. For ease of removal and cleaning, be sure to leave a finished opening at the back or a side seam that can be closed with buttons, Velcro®, or ties. Or create an opening at the back of the slipcover by simply overlapping the fabric. If you don't own a sewing machine, waterproof glue may be applied to seams on small projects.

To enhance this beige, pleated pillow I used a hemmed strip of coordinating fabric. This is an easy sewing project, and the decorative piece of fabric can be slipped on and off the pillow for greater versatility.

∧ *(Top) These once ordinary outdoor chairs have been decorated with easy-to-sew fabric slipcovers and pillows. The top on the side table was replaced with a large brass tray to add elegance.*

(Bottom) Ties attached to this slipcover allow it to be easily removed for cleaning.

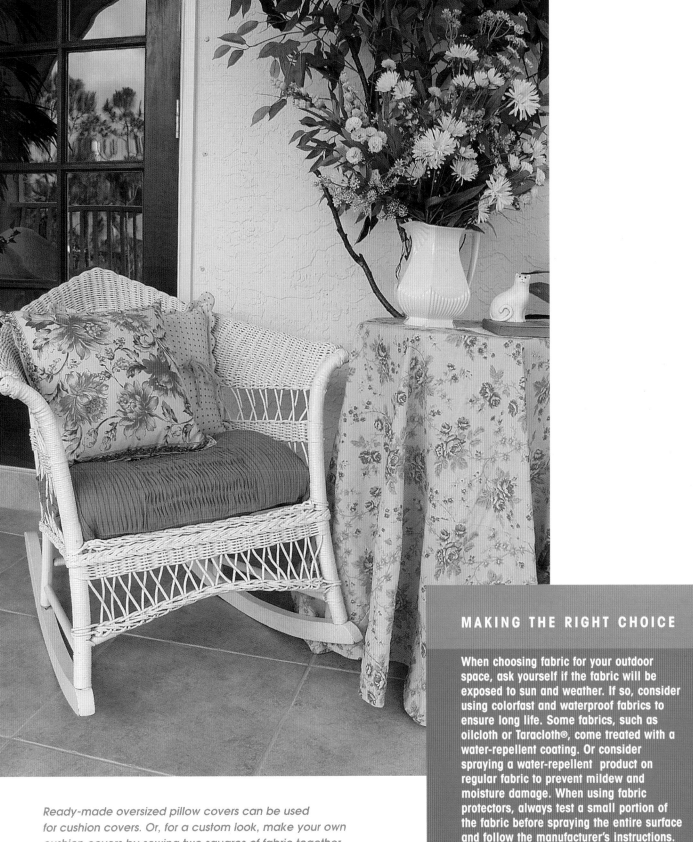

Ready-made oversized pillow covers can be used for cushion covers. Or, for a custom look, make your own cushion covers by sewing two squares of fabric together.

MAKING THE RIGHT CHOICE

When choosing fabric for your outdoor space, ask yourself if the fabric will be exposed to sun and weather. If so, consider using colorfast and waterproof fabrics to ensure long life. Some fabrics, such as oilcloth or Taracloth®, come treated with a water-repellent coating. Or consider spraying a water-repellent product on regular fabric to prevent mildew and moisture damage. When using fabric protectors, always test a small portion of the fabric before spraying the entire surface and follow the manufacturer's instructions.

From Common to Custom

Gather leftover fabrics to create custom patchwork pillows or cushion covers. I enjoy handpainting, tie dying, stenciling, and stamping fabric. There are many products available for this type of project. Remember to always follow the manufacturer's instructions for the best results. Embellishing fabric with paints or dyes can be a great craft project and very gratifying. Even painting simple shapes such as circles, lines, or swirls can make a big impact. Just use your imagination and go for it. You might surprise yourself.

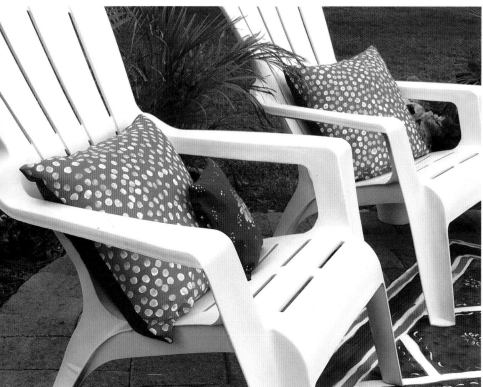

∧ *A rolled-up orange towel was used as an accent and doubles as a pillow. The blue color on the pillows contrasts nicely with the white slipcovers on the cushions, while the painted orange flowers coordinate with the new color of the metal patio furniture.*

< *These pillows were made from leftover fabrics that were hand-painted with acrylic paints for a custom look.*

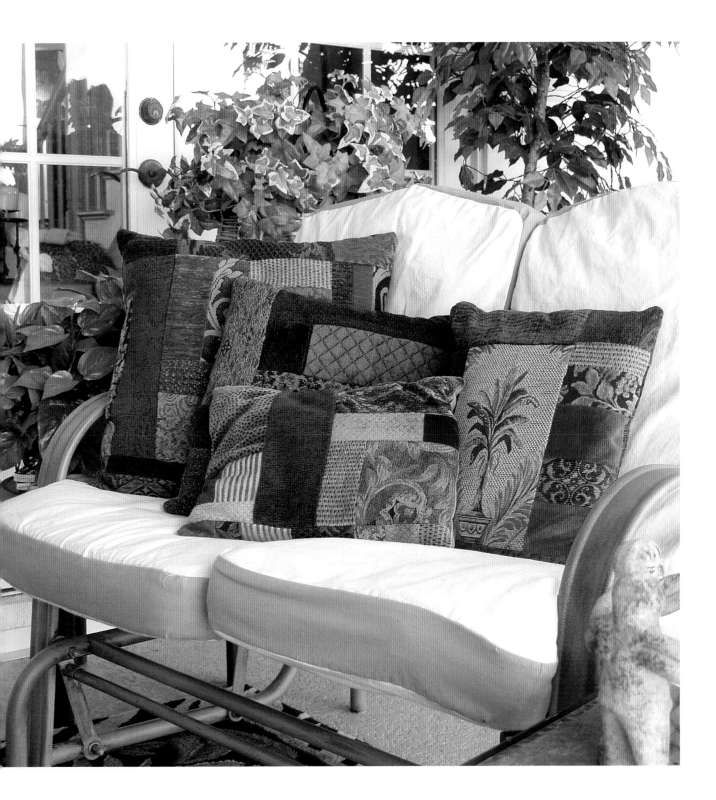

Leftover fabric remnants were used to create these custom throw pillows.

BEFORE-AND-AFTER FILE

When I started to recruit my friends, friends of friends, and family members to be participants in the outdoor makeovers in the "Before-and-After File," I found that everyone was thrilled to have me redecorate their outdoor living space, especially on a budget of $250 or less. Each home owner was responsible for keeping tabs on the budget, and since it came from the owners' pockets they had added incentive not to over spend. I promised them that by using creativity and resourcefulness, they would have the look of a high-budget makeover.

Though most everyone was open to my suggestions for color and style, I had a few initial protests. But, by the end, I had gained everyone's trust and all of them were glad they took my advice. During the makovers everyone pitched in, learned something new, and enjoyed the creative process of redesigning. But the most exiting part of each makeover was the sheer delight everyone experienced when the projects were completed. Although all the outdoor spaces in the "Before-and-After File" are located in Florida, all of the designs can be used for a terrific makeover in any climate or region.

Colorful Patio Transformation

TERRA-COTTA, WHITE, AND NAVY BLUE

In general, if patios are in good condition, they are an easy makeover project. Unlike a porch, a patio is not covered by a roof and, like this example, may not have any adjoining walls to paint or decorate. A patio makeover solution may require only rearranging furniture or giving furniture a fresh coat of paint. The simple addition of some new cushion covers and a few potted plants can complete the new look.

The home owner of this fun patio makeover is my sister-in-law Elaine. The exterior of Elaine's house is the color of a sun-kissed Florida orange. She had recently built her paved patio and was using it for family barbeques and sunbathing. In general, Elaine was very happy with the original look of her patio. When I suggested that we lighten up the cast-iron furniture with some bright orange colors to connect her new patio to the exterior of her home, she didn't blink an eye. Elaine has no fear of color and went right to work spray painting the black furniture a yummy terra-cotta color. Though Elaine didn't think her blue cushions needed a facelift, with a little persuasion I convinced her that the overall look would be much cleaner with new white cushion covers. With a few extra makeovers, Elaine now has a fresh new patio that is inviting for both entertaining and sunbathing.

v after

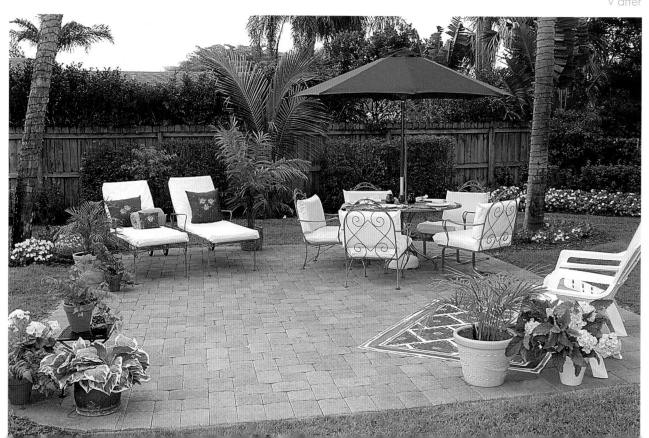

PERFECT PATIOS

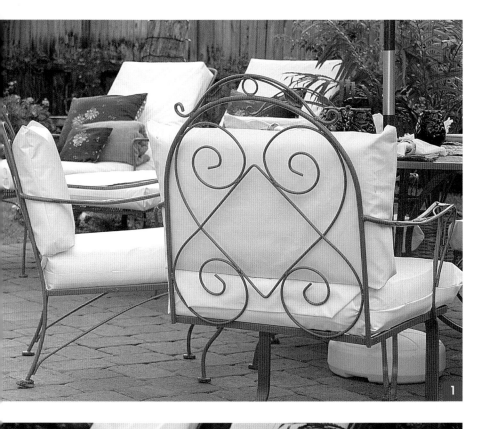

Here's what we did:

1 First we washed the cast-iron furniture and removed any rust spots with a wire brush. We then spray painted the furniture terra-cotta and replaced the undersized beach umbrella with a navy blue patio umbrella that Elaine had previously purchased but had never used. With her busy work schedule she had not had time to put the new umbrella in place. The navy blue umbrella became the basis of the second color in her patio makeover scheme. Next, we cut and sewed waterproof Taracloth® slipcovers for each cushion. Taracloth is a stiff, canvaslike cloth that is treated with a waterproof coating, making it easy to clean and great for outdoor use. It is available at art supply stores. Since Taracloth is stiff, sewing the cloth was probably the most challenging part of the project, but well worth the effort. The fresh white slipcovers helped make the detail on the ironwork "pop." If Elaine tires of the white, she can paint, stencil, or stamp the Taracloth for a custom look.

2 For a coordinated look the tabletop was accessorized with blue candle globes, white plates, and bright orange placemats.

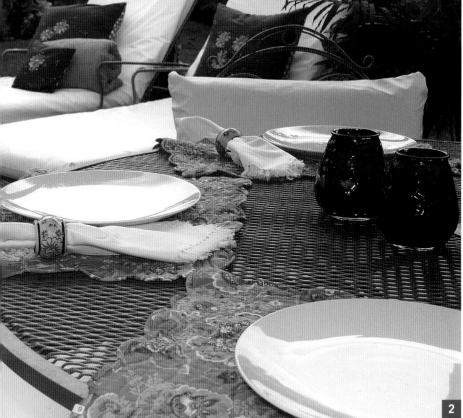

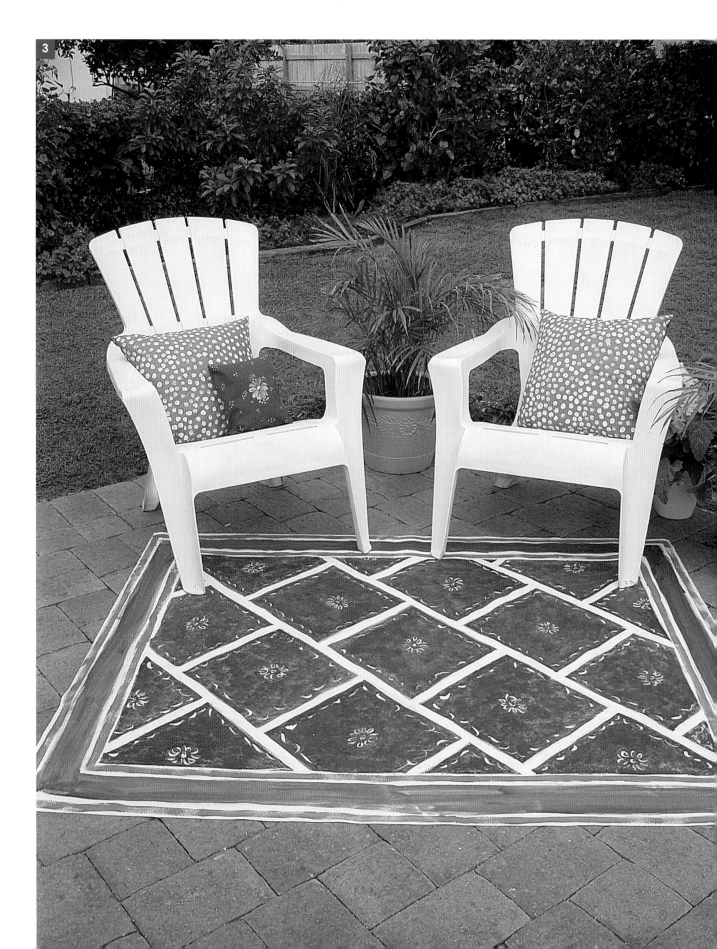

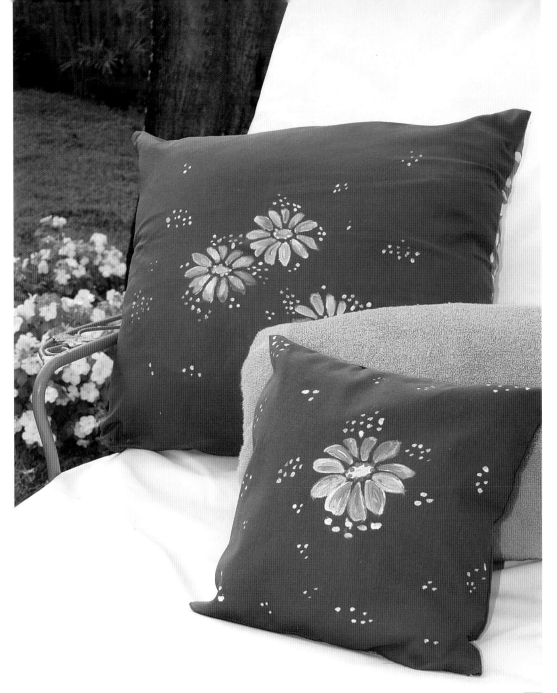

4

3 Originally green, the two Adirondack-style plastic chairs were spray painted white and moved to the opposite corner of the patio. (Since the chairs are plastic I needed to use a paint product specially formulated for plastic surfaces. Krylon®'s Fusion Paint for Plastic is my personal favorite.) Then, using craft paint, I hand-painted and stenciled a floorcloth navy blue, white, and orange to help coordinate the furniture and the rest of the accessories. (Floorcloth is available at craft and art supply stores.) The colorful floorcloth also helps to create a distinctive and comfortable seating area. Your job will be even easier if you start with floorcloth that is primed and precut. To complete the floor-cloth, fold the edges under and secure them with glue. Don't forget to apply a water-proof sealer to floorcloth to protect it from weather and foot traffic.

4 I made and scattered hand-painted pillows to add a custom look and a touch of whimsical pattern.

5

Here's what it cost:

$29	9 solid bandannas for 6 pillows and pillow forms
$36	Krylon®'s Interior/Exterior spray paint for the iron furniture and Fusion Paint for Plastic for Elaine's 2 green plastic chairs
$98	Taracloth® All-Weather Sign Cloth for the white cushion covers
$38	Frendrix® floorcloth canvas for the blue, handpainted rug
$4	Delta Ceramcoat® acrylic paint for the floorcloth and pillow designs
$24	Perennials and plants for the patio corners
$229	Total Cost

(DOES NOT INCLUDE SALES TAX)

5 To soften the corners of the patio we planted color-coordinated annuals along its border and strategically placed a few potted plants.

Here's what Elaine said about the transformation:

Before the makeover, I thought my patio looked good. I finally had a place to put all that furniture. Then Kathy gave me some ideas on how I could really make it look nice on a small budget. She was so right. Now it looks fresh, clean, inviting, and ready for entertaining. Painting the furniture a bright color that complements the color of my house, covering the cushions in white, and adding an accent of blue with the umbrella and some throw pillows made all the difference in the world. I just love the new look of my patio and my guests will too!

Pretty Patio Revival

PAPRIKA, BRASS, LICHEN, AND LIGHT GREEN

> before

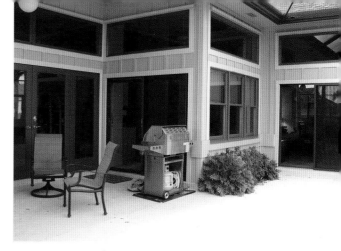

My neighbor Carol's patio is spacious and had nice furniture, but it lacked color, and her grill was the first thing you saw when you walked out onto the patio. Since their patio was devoid of any welcoming charm, Carol and her husband only used their patio for grilling. I suggested we bring the colors from her kitchen and den out to her patio by using leftover fabric, pillows, and plants she already had on hand. This simple transformation, which required just a little bit of sewing, would enable Carol to use her patio for occasional entertaining. By making a couple of simple slipcovers for two of her patio chairs, regrouping the furniture, buying a couple of new rugs, and adding a few pillows, some linens, and lots of greenery from inside her home, Carol now has a wonderful outdoor retreat that is full of color.

v after

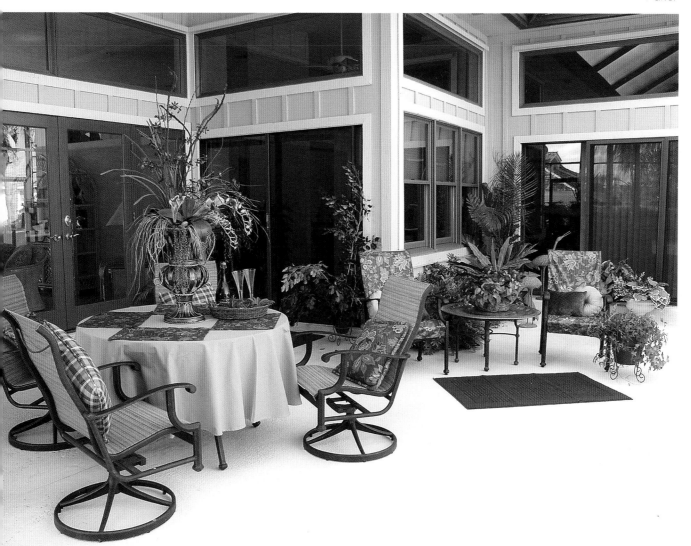

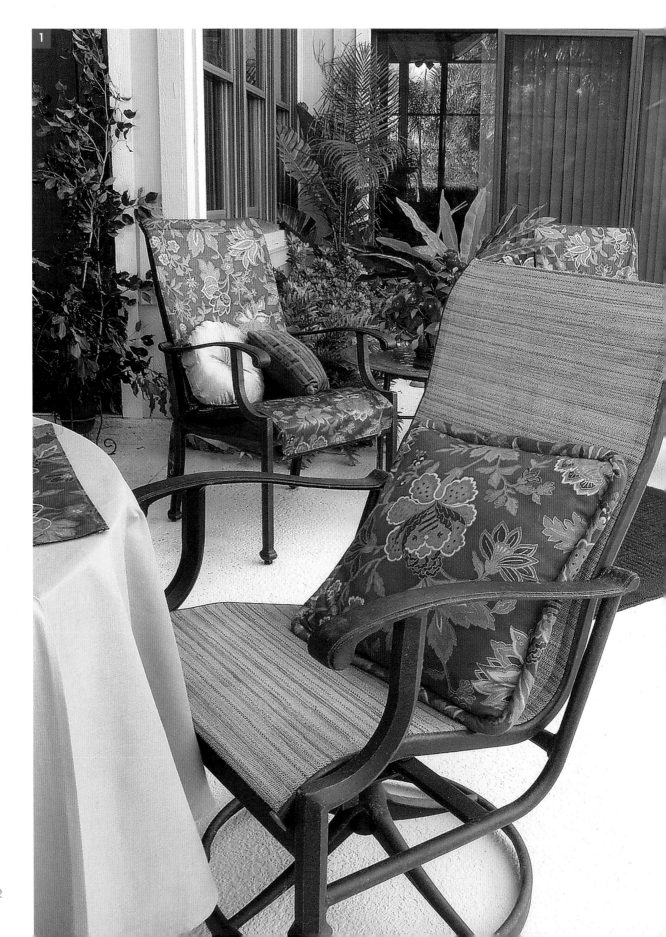

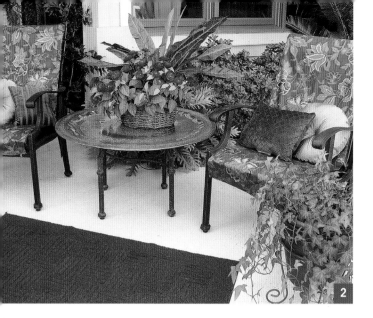

Here's what we did:

1 We used pillows, leftover fabric, and plants from inside Carol's home to help transform her patio into a welcome outdoor retreat.

2 To add drama and sparkle to this once barren outdoor space we grouped two of the chairs together, anchored the floor with a coordinating rug, and covered her side table with a wonderful brass tray.

3 To add even more interest, I placed two bird sculptures from her living room directly behind the seating area. We placed greenery near the sliding glass door to create a natural garden look. This softens the hard concrete floor and adds color to what was formally a blank space. It quickly became my favorite point of interest for this patio makeover.

4 Simple slipcovers made from Carol's leftover fabric added color. The slipcovers are nothing more than a long rectangle of fabric that covers both the front and backs of the chairs and are secured with some simple tie tabs.

For entertaining purposes, use a large dramatic centerpiece to attract attention. Cut tree or shrub limbs and place them in containers to add more color and to soften edges and corners. This is a great way to create a fresh, natural look without paying for live or silk plants.

5 Next, her table and four chairs were repositioned away from the back wall and slightly off center from her living room doors. The grill was moved to the opposite end of the patio. Pillows and a rug were added for additional color and comfort. For an incredible statement we then placed a dramatic centerpiece on the table that included all of the colors from inside her home. A new tablecloth and some place-mats made from her leftover fabric added even more color and interest.

Here's what Carol said about the transformation:

When I thought of my patio, I never could imagine it as a place that could be stylish, much less a venue for entertaining. As you can see from the "before" shots, I lacked any sense of design. Kathy came to my patio with her eye for warmth and color and "Bam!" She created an extension of the inside of my home with very little effort and much less expense. What a difference she made.

Here's what it cost:

$70	2 rugs (one for the entry to Carol's kitchen and one for a seating area)
$69	1 tablecloth for the patio table
$30	Fabric and pillow forms for sewing additional pillows
$169	**Total Cost** (DOES NOT INCLUDE SALES TAX)

Exotic Porch

TAN, CHOCOLATE BROWN, OLIVE GREEN, PAPRIKA

When I think of porches, I think of resting places to enjoy a cup of coffee with a newspaper, a friendly gathering place for friends and family after a big meal, or a quiet place for solitude and meditation. Since a porch is often the first part of your house your guests will see, it's extra important to make it look nice and welcoming.

My daughter-in-law Peggy knew this was exactly the change her porch needed. It had great beginnings and sturdy furniture, but it lacked the color and coordination needed to make it truly welcoming. Her furniture was in terrific shape, but the fabric and the color of the wicker was in need of a facelift. Peggy loves the color brown, and was excited by my idea to paint the wicker furniture a chocolate brown. But she wasn't quite sure about selecting a fabric. After some shopping, Peggy found a brown monkey print that echoed the colors in her living room. Though reupholstering her chaise lounge and ottoman was a big project, it was worth it; in the end it looked as though she spent a small fortune on the makeover. It was a fun project to work on, and now her porch feels like an extension of her living room.

v after

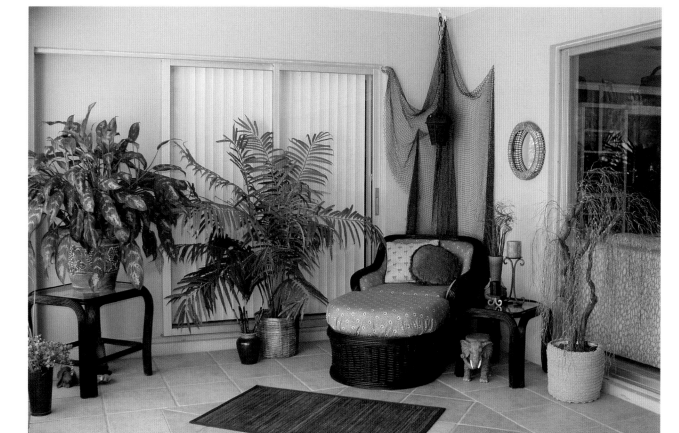

Here's what we did:

1 After removing the old, dingy upholstery, I used it as a pattern for the new fabric. (Note: Be careful when removing seamed upholstery with tacks so you don't cut yourself, and in case you'd like to use the old upholstery as a pattern.) I then cut and sewed the fabric to fit the chair and ottoman and set it aside. The tables, chair, and ottoman were cleaned, spray painted black, and then lightly over sprayed with leather-brown spray paint to create a mottled chocolate brown color. This wonderful technique—using more than one color of paint—will allow you to achieve an expensive designer look at a fraction of the cost. Together, Peggy and I made pillows from leftover fabrics, stapled and glued the fabric to the chair and ottoman, and then glued green cording around the edges of the chair and ottoman for a finished look.

2 We removed the odds and ends of wall decorations and added plants, a fish net, a new rug, and accessories from inside the house to give this corner a soft and tranquil feeling.

3 Remember the old pink flowering tree in the "before" shot? We removed the dusty, faded pink silk flowers and replaced them with interesting foliage, and Peggy now has a unique tree.

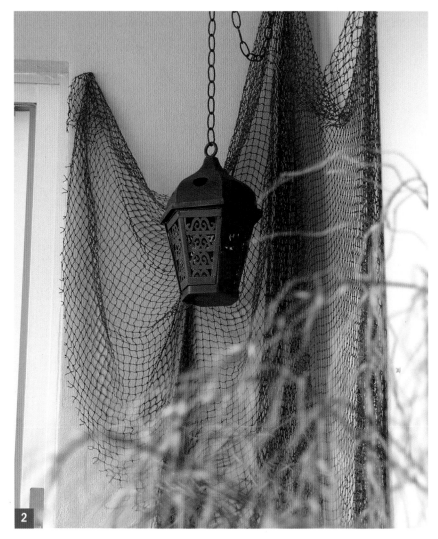

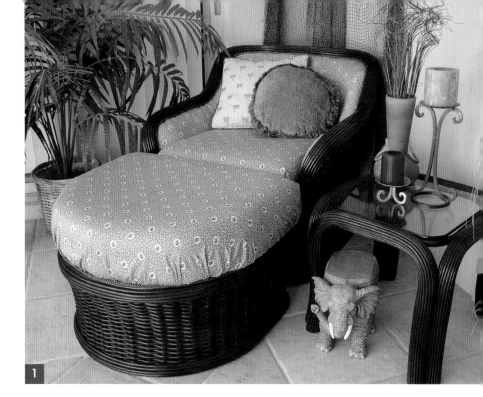

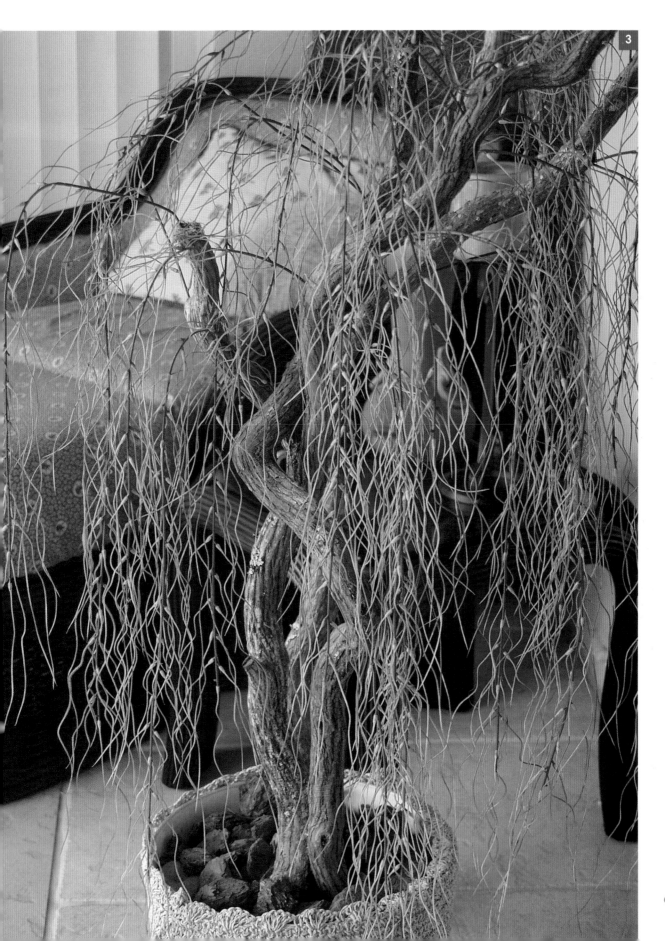

5

DESIGNER TIP

Tackling a reupholstering project can be quite challenging for the beginner. However, with a little patience, and removing the fabric carefully for later use as a pattern, home owners can save hundreds of dollars and achieve a professional look for only the cost of fabric and trim. Though our $250 budget didn't allow it, I would have liked to add a matchstick or bamboo blind over the sliding glass door to add more texture.

4 An existing beige plastic pot and live plant were moved from inside Peggy's home to this spot. To add charm to the plain beige pot we rubbed brown and black artist's acrylic paints on the relief areas.

5 In keeping with the palette, we grouped burgundy and tan candles on the side table to add color accents and to create soft lighting.

Here's what Peggy said about the transformation:

I had used my porch as an outdoor gathering space for friends and family, but I was never happy with the way it looked and was never sure how to decorate it. Kathy went to town transforming my hand-me-down patio furniture with paint and fabric. The result is a lovely new porch with an exotic theme that now gets a ton of compliments. Along the way, Kathy taught me painting, sewing, and reupholstering tech-niques, and I had a great time doing the makeover.

> before

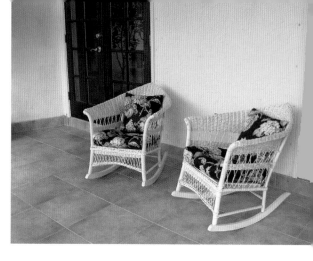

Wonderful Wicker

TANGERINE, WHITE, AND GOLDEN YELLOW

My friend Mickey's covered porch was an easy makeover. Her house is filled with an eclectic collection of family heirlooms and Victorian furniture. Her lovely antique wicker chairs were flanked by two double French doors, but they just seemed to float. By simply adding plants and a small table, and changing the colors of the cushions, Mickey now has a cheerful outdoor space she can enjoy year round.

v after

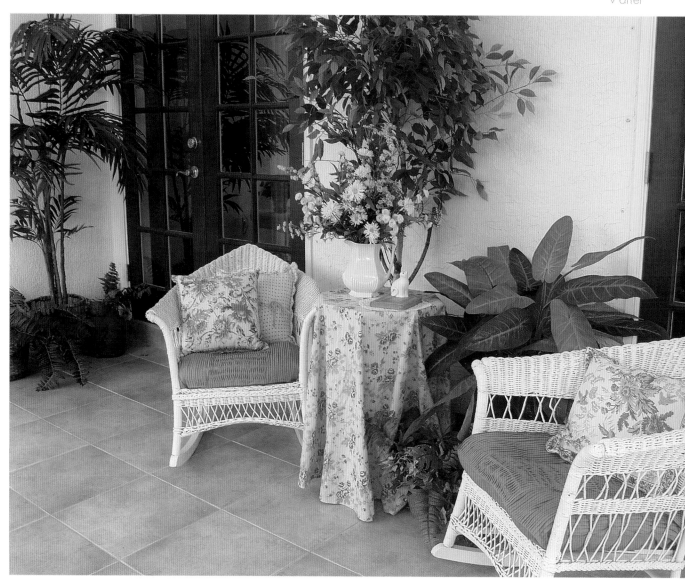

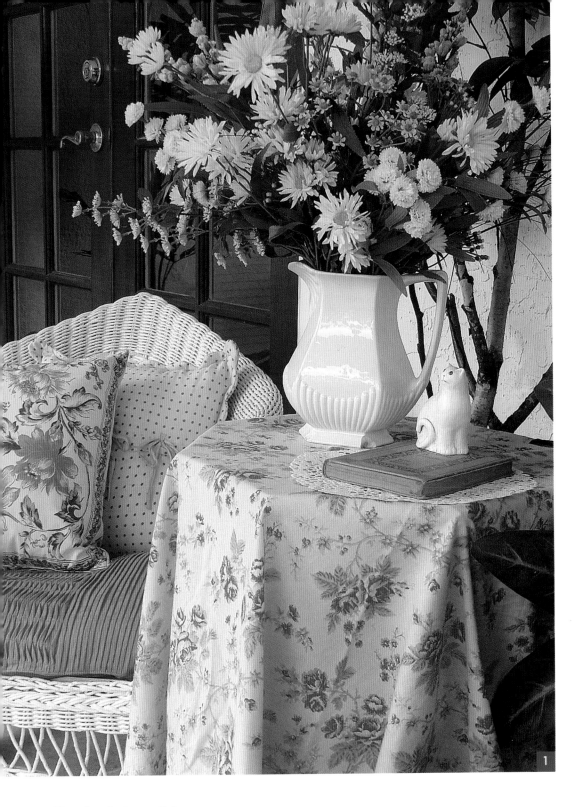

Here's what we did:

1 We exchanged the existing black pillows for brightly colored cushion covers in various shades of peach and yellow. This helps to brighten up and accent Mickey's antique wicker chairs. To make the setting more functional, I added a small round table and covered it with a coordinating tablecloth.

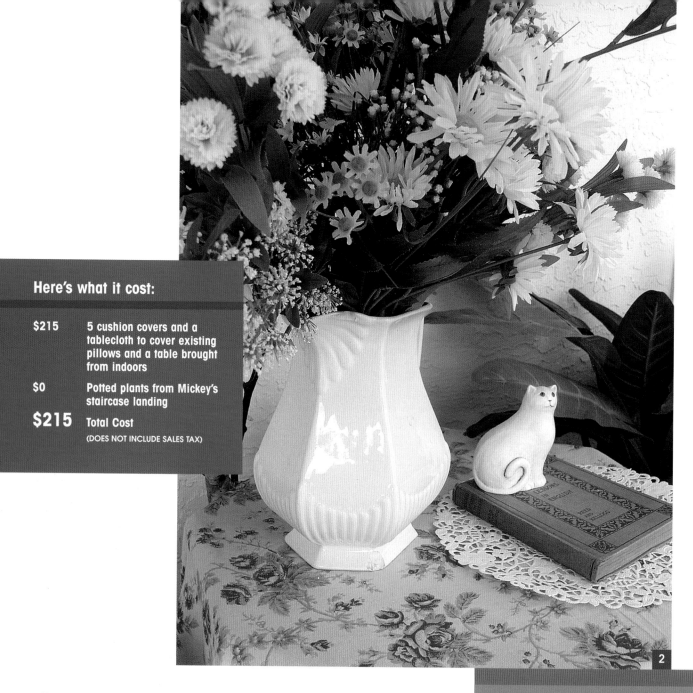

2 Plants, cut flowers, and a few more accessories taken from inside the house were used to soften the edges and to add layers of interest.

Here's what Mickey said about the transformation:

With Kathy's vision and talent, my two lovely wicker chairs were transported to a serene porch setting that is ideal for quiet conversation. We now have a special spot we'll enjoy for years to come.

DESIGNER TIP

To accent pretty porch furniture, think color! If you choose to leave fabric-covered pillows on a covered porch, use a water-repellant spray to protect them from moisture and soiling. Also, choose colors that will work inside your home; that way, if you don't want to leave the cushions outside, you can enjoy them inside too.

Corner Rocker Retreat

WHITE, PEACH, AND BRIGHT YELLOW

My friend Laurie's front porch was large and expansive. It lacked color so I chose a neutral peach color (a color that would work well with Laurie's neutral interior colors) to help give this shady porch a splash of color. To create a cozy setting with a feeling of enclosure, I decided to disguise the porch railing with foliage and add colors of peach and yellow for a soft feminine look. Talk about a fast and easy makeover with grand results!

∨ after

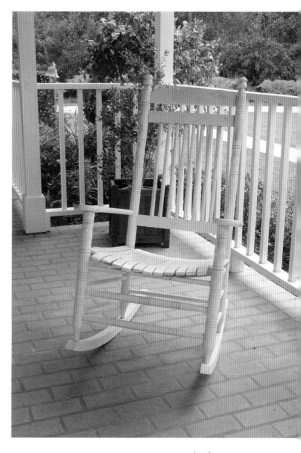

∧ before

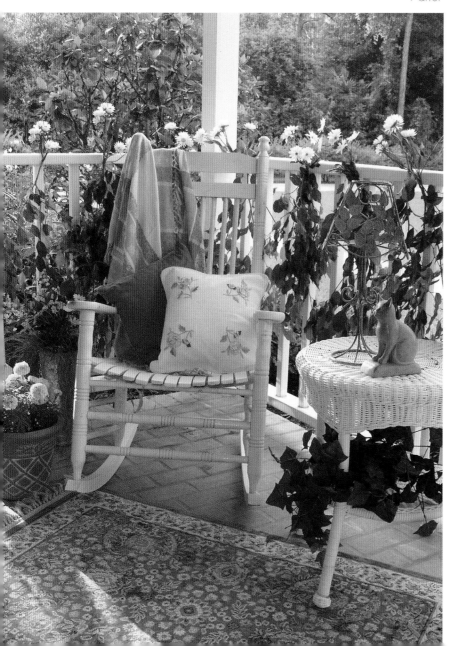

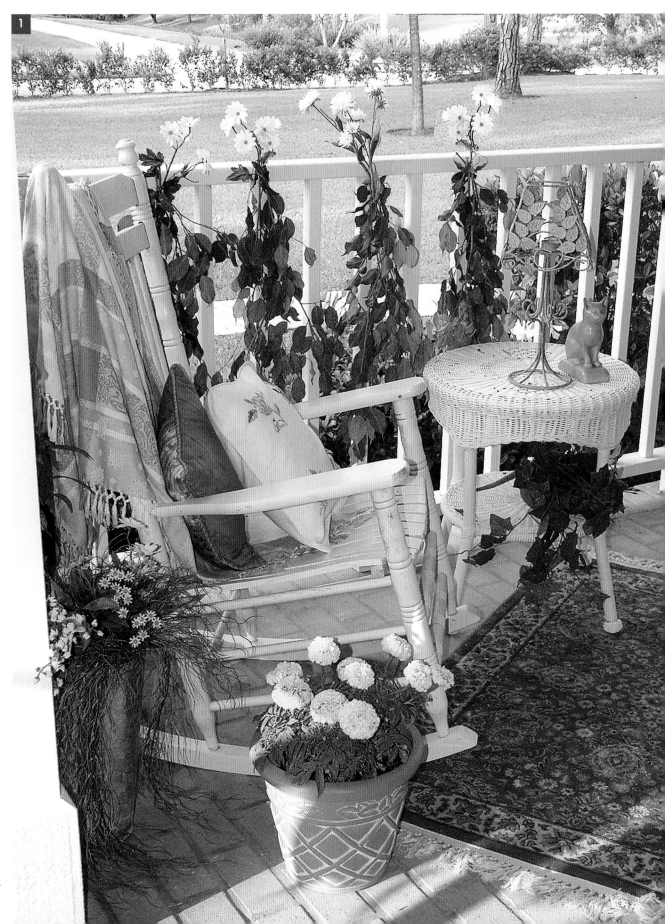

2

Here's what we did:

1 To soften the floor I used planted mums and a plush rug. These simple accessories pulled this area together with ease.

2 I moved a small, white, wicker table from another area of Laurie's porch and added a few tabletop accessories to coordinate with the pillows and throw.

3 No electricity is needed here for an evening cocktail. This little lamp is actually a votive candleholder and creates atmosphere in the evening.

4 To soften the white repetitive lines of the railing, I tied cut greenery and daisies and secured them to every other banister.

Here's what Laurie said about the transformation:
This spot on the porch was rarely used; now it's the family favorite! It truly has become an extension of our family room. We love it!

Here's what it cost:

$0	Flowers, cut greenery, and potted plants from Laurie's yard
$22	2 pillows for the rocker
$65	Rug for the porch floor
$39	Jacquard throw
$126	Total Cost
	(DOES NOT INCLUDE SALES TAX)

Benchmark Makeover

NATURAL BROWN, MUSTARD, DARK GOLD, AND SPRING GREEN

What was already a nice seating area has been transformed into a comfortable outdoor room. Simply by adding pillows, cushion covers, and a handpainted rug, Laurie's porch has been transformed into a colorful and inviting place for relaxation.

> before

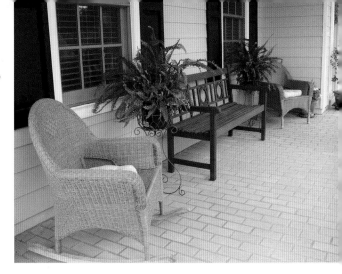

v after

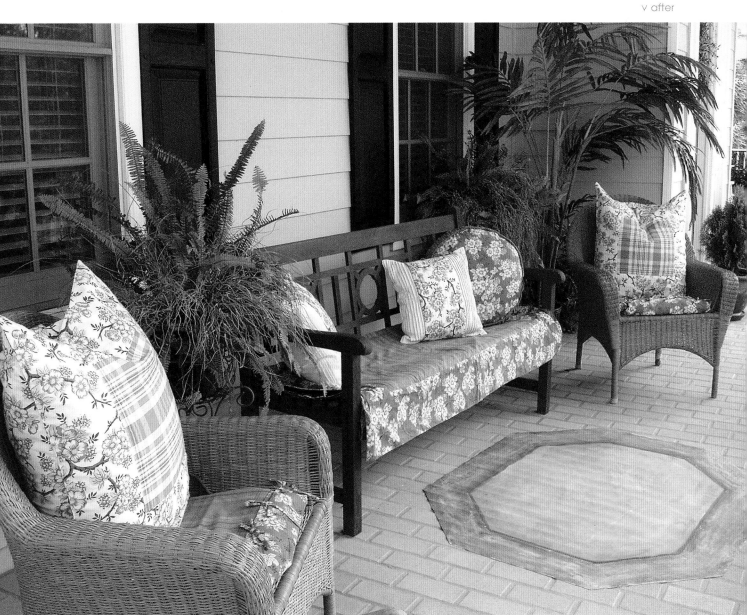

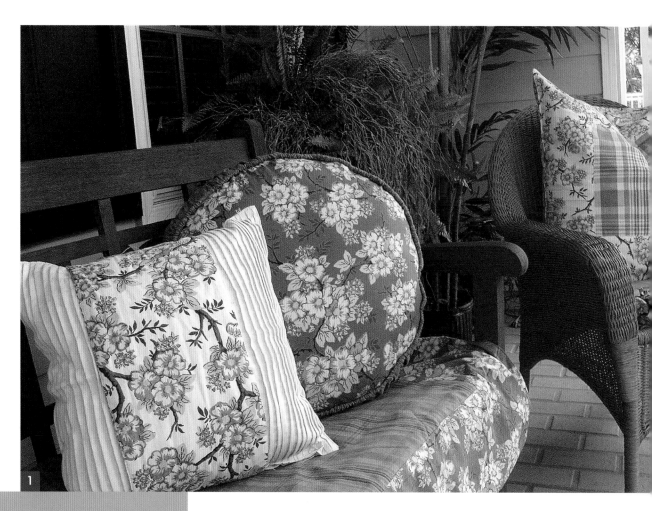

Here's what we did:

1 Laurie has wonderful antique furniture throughout her home. Her lovely antique-filled living room was overflowing with warm wicker shades and other natural colors. With that as my inspiration, I decided to bring her living-room colors onto her front porch. Using a coordinating tablecloth and ready-made pillows, we added comfort and color in just a few minutes.

2 Adding plants helped soften the edges and corners, and made this outdoor space more welcoming. Pulling the colors from the tablecloth fabric, I painted an octagon-shaped floorcloth to give this space another focal point.

Here's what Laurie said about the transformation:

Kathy created a cozy vignette showcasing our bench as the centerpiece of the porch. The mixture of the different fabrics and textures is charming, and I love the color combination!

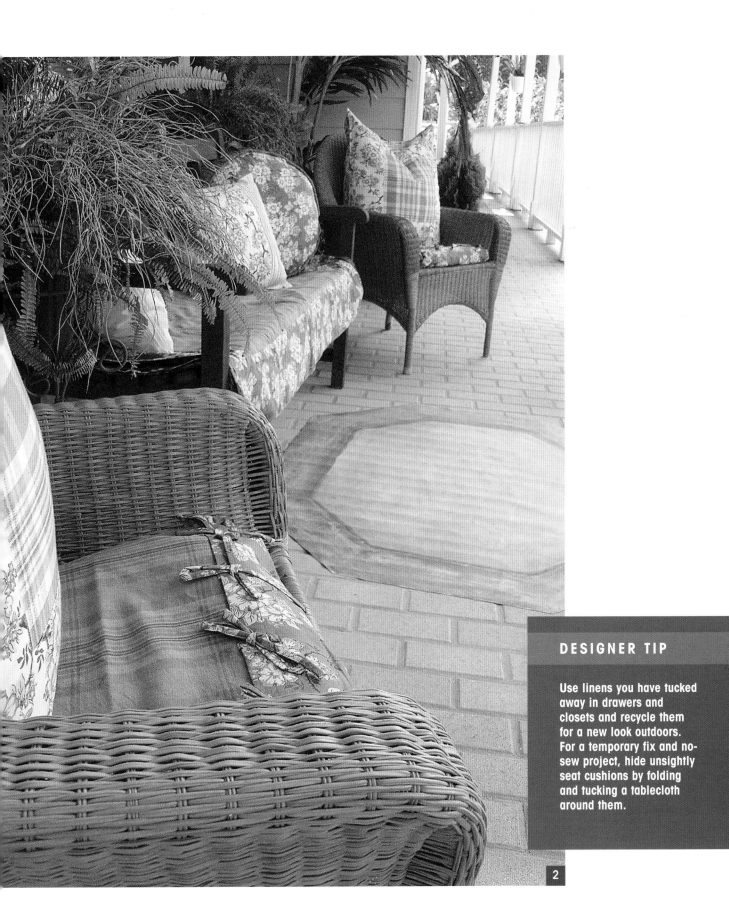

2

White Magic

PERIWINKLE AND WHITE

As a designer, I find that I tend to take care of everyone else's needs while neglecting my own. This book was the perfect opportunity for me to get going on several much needed outdoor makeovers of my own. I'm embarrassed to say that my porch had become a hodgepodge of flea market finds and that my plants had been terribly neglected. To pull my favorite colors from inside my home to the outside, I decided to paint everything white with blue accents. My husband and I love the color blue, so it was a natural choice to bring these colors out to our porch. With some replanting, a little plant food, and fresh paint, I had a fresh, clean look that actually made my porch look bigger and brighter!

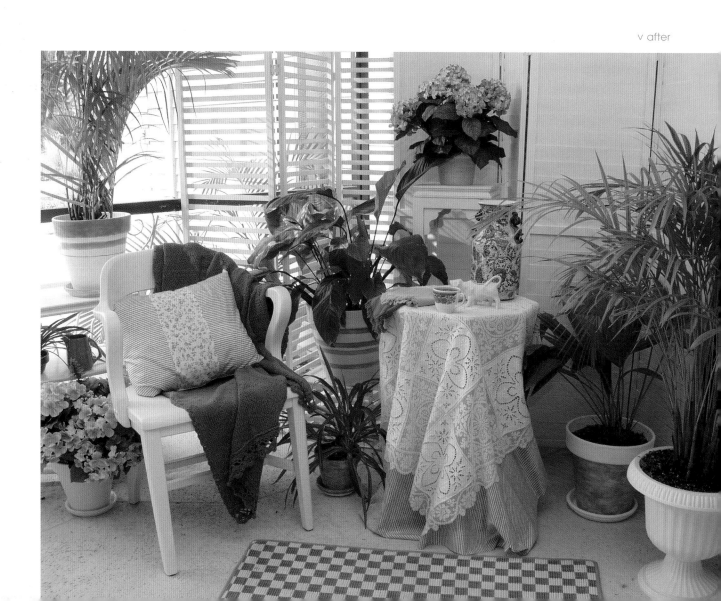

< before

v after

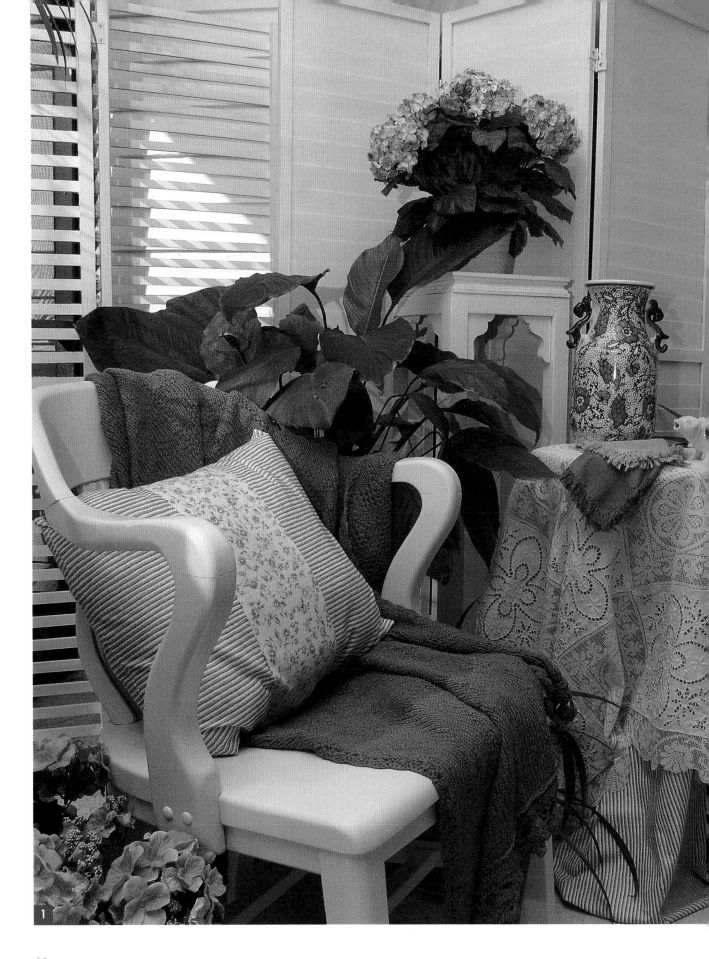

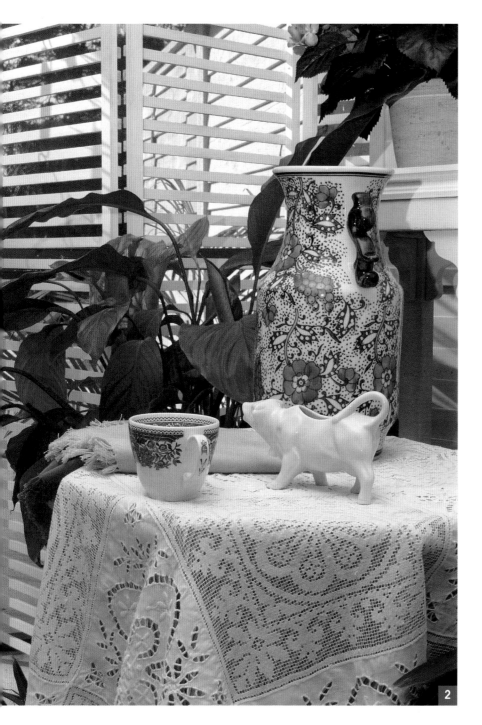

Here's what I did to the seating area:

1 All the furniture, porch walls, and pots were given a fresh coat of white paint. Next, I removed one of the chairs and added pillows, a blue-and-white rug, and a small, round covered table. I dug out some old terra-cotta pots and potted some pretty hydrangeas to accentuate the blue color scheme. I pulled an old room divider from my storage area and spray painted it white. The refreshed divider added brightness to the corner and disguised the dark reflection of the sliding glass door. The original room divider, which we left in its original position, also got a fresh coat of paint.

2 Next, I draped fabric left over from my pillow design and an antique tablecloth over a side table. I then placed some pottery pieces from my kitchen on the table for more interest, color, and pattern.

3 I accented the newly painted white pots with blue stripes for added interest and gave my plants a welcome dose of much needed fertilizer.

Here's what I did to the dining area:

4 On the opposite end of my porch I spray painted the drab pine table and chairs solid white and layered folded napkins for placemats. A mixture of fresh purple petunias and hydrangeas added a splash of color on the table.

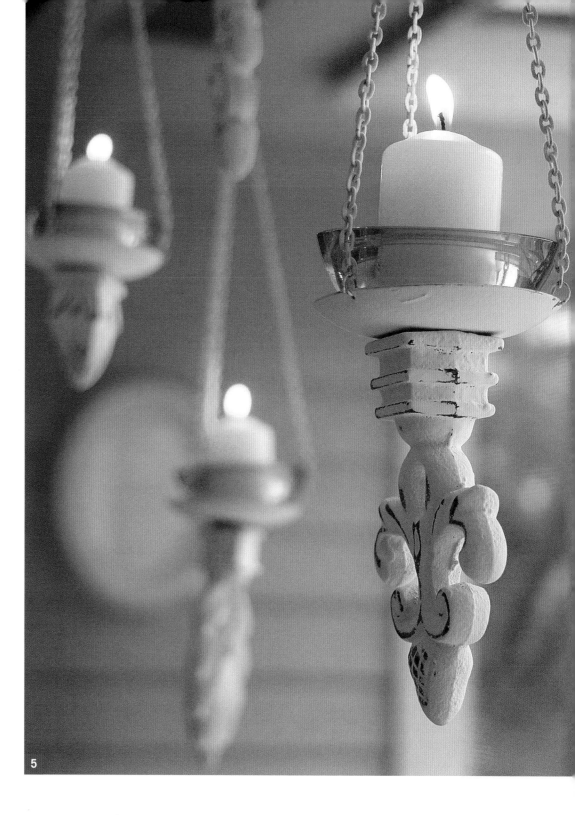

5

5 For ambiance and mood I hung several attractive candleholders near one of the newly painted porch columns. I used some blue glass votive holders I had on hand for added color.

6 To paint the stripes on my pots, I used Delta Ceramcoat Acrylic Paint color Bahama Purple (#2518) and placed the pots on a lazy Susan. By rotating the pot on the lazy Susan and keeping a steady hand, you can achieve a much more professional look. When using craft paint, be sure to seal your paint project with an acrylic sealer, especially if it's going to be exposed to water. Paints may be substituted, but always read

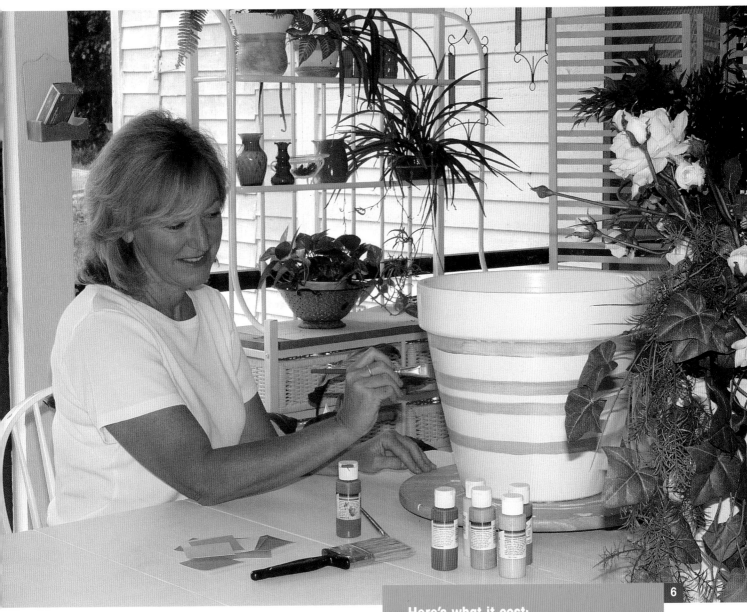

the manufacturer's instructions to insure it will adhere to the surface you are working on.

Here's what I said about the transformation:

In its previous life my porch seemed dingy, dull, and unattractive; but with a fresh coat of white paint and some blue accents, I now have a porch that is cheerful and great for outdoor entertaining. Since my porch is fairly long, I divided it into two distinctive areas. I'm so pleased with what I accomplished, and I'm especially pleased I came in under budget!

Here's what it cost:

$37.50	**12 April Cornell napkins and placemats to add color to my tabletop**
$34	**Terra-cotta pots and saucers for plants**
$65	**Krylon® Interior/Exterior spray paint and Krylon Gesso Spray for all the wood furniture**
$61	**Exterior paint for porch walls**
$12	**Potting soil and plant food**
$36	**6 finial candleholders**
$245.50	**Total Cost** (DOES NOT INCLUDE SALES TAX)

6

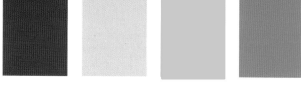

Safari-Style Porch

DARK BROWN, KHAKI, PAPRIKA, AND OLIVE GREEN

> before

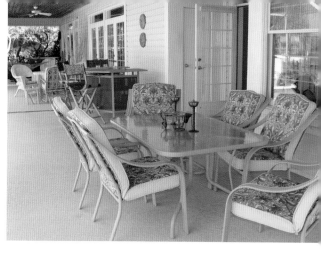

My neighbor and friend Jennifer has a huge back porch—seventy-feet long to be exact. She had already established four sections of the porch, including a catch-all area, a seat-ing area, a bar, and a dining area. The challenge was, of course, stretching the $250 budget to encompass the whole porch while hiding the catch-alls. There are lots of wonderful shades of brown and natural wicker inside Jennifer's house, so we brought the inside out, carrying Jennifer's living-room and kitchen colors onto the porch. And wow, what a difference for only $237!

v after

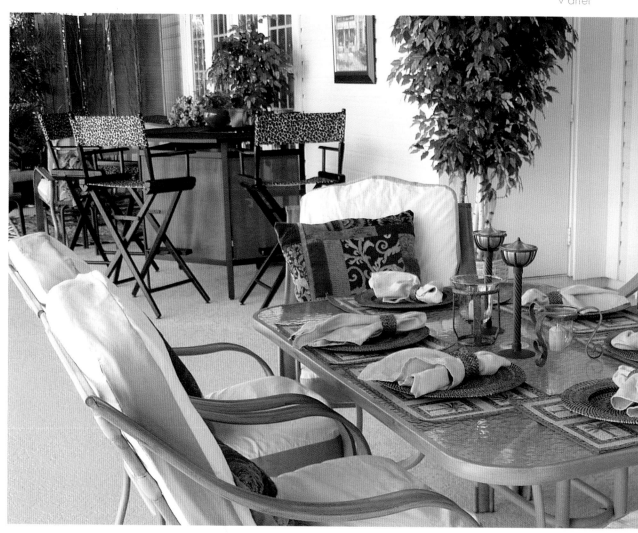

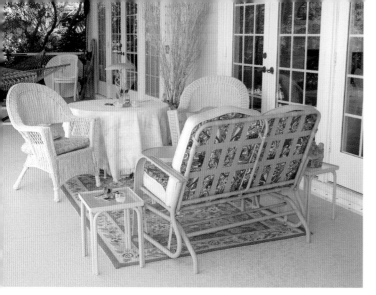

< before

v after

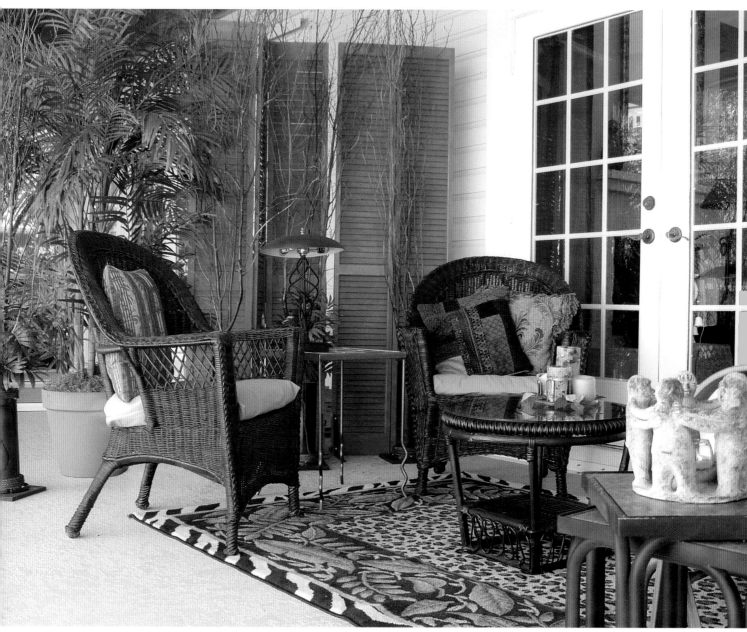

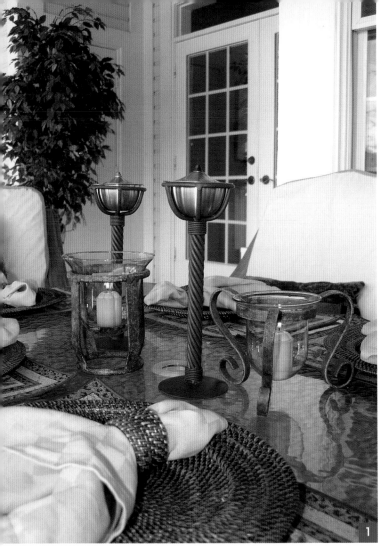

Here's what we did to the dining area:

1 All of the matching chairs and table were rubbed with a brown stain to give the original sandy color a little more depth and richness. For a touch of color, we made easy-to-sew slipcovers and a few pillows from fabric Jen had on hand.

2 Jennifer already had some great table accessories so the only thing we had to purchase to continue the safari theme were six placemats. Last of all, a silk tree from inside her house was brought out to soften and hide a storage door.

3 When entertaining, make sure that there is easy access around the seating area, both for you and your guests and to bring food and beverages.

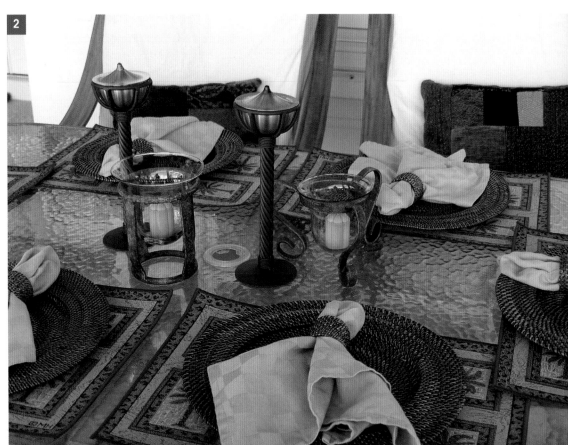

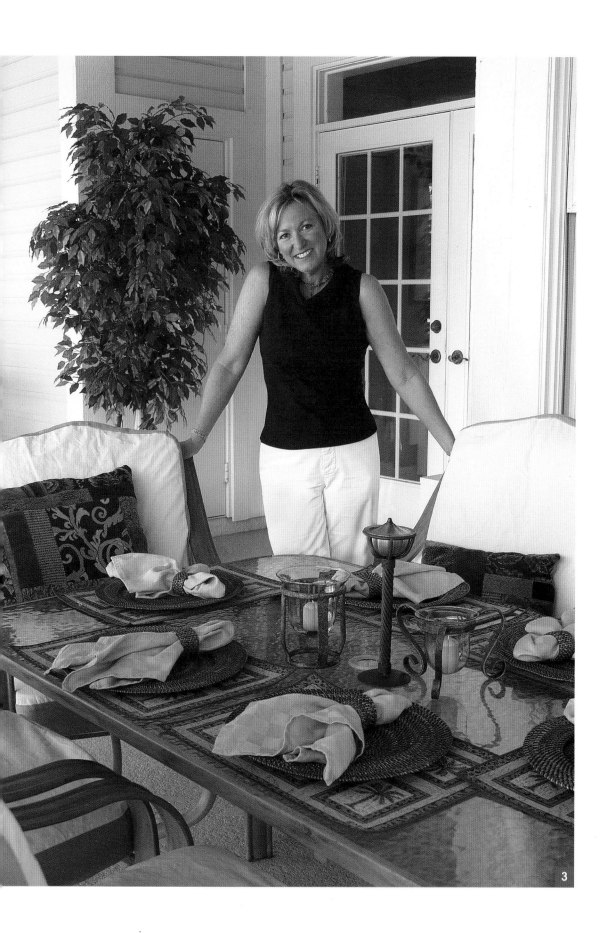

Here's what we did to the seating area:

4 Using black and brown spray paints, we painted the once white twigs. Next, a base coat of black was sprayed onto the wicker chairs. They were then lightly dusted with leather brown spray paint. Jen applied the same painting technique to a discarded round wicker table that she had found. We then added a round piece of glass.

5 Using the same scrap fabrics, more pillows were made. We discarded the oversized round table that originally sat between the chairs. We replaced it with a smaller spare table from inside Jen's home that made more sense in the space.

6 The turquoise rug was replaced by a newly purchased rug with a brown, green, and burgundy safari print. The new rug pulled together the colors of the furniture, accessories, pillows, and slipcovers. The stacked tables on Jen's porch were painted green, and a peel-'n'-stick tile was placed on the glass top of one of the stacked tables for more interest.

6

7

8

7 The catchall area was an eye-sore, but there was no other available storage space. Our solution was to spray paint lou-vered closet doors that Jen had found in the trash a soft brown. The once beige lamp was spray painted burgundy and black. We used silk plants that Jennifer already had to soften this hard surface. Jen had a great idea for simple and inexpensive containers—PVC pipes. The pipes were cut at the hardware store and then painted and mounted to scrap wood to hold twigs.

8 A few more pillows were made from scrap fabric and slipcov-ers were made from the canvas Jennifer also had in her fabric stash. The glider was rubbed with a brown stain to darken the sandy color, and additional silk plants from inside her house were placed behind the glider.

DESIGNER TIP

When working in a large space, spend your money wisely. Often you'll have items from inside your home that will transfer nicely to your outdoor space. In Jennifer's case, she had lots of good things to work with that helped to save her money.

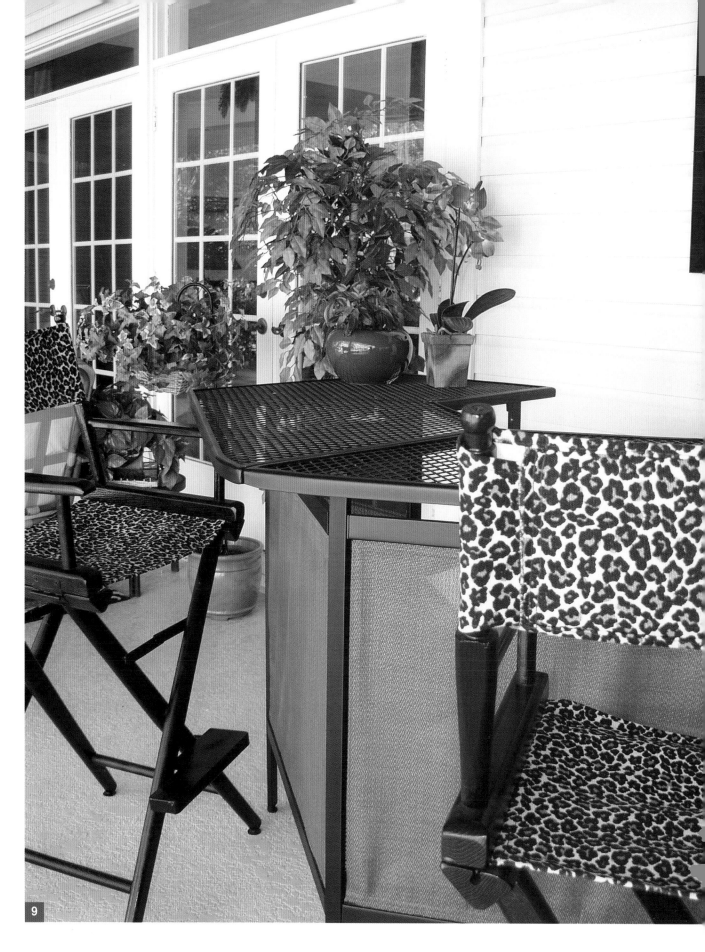

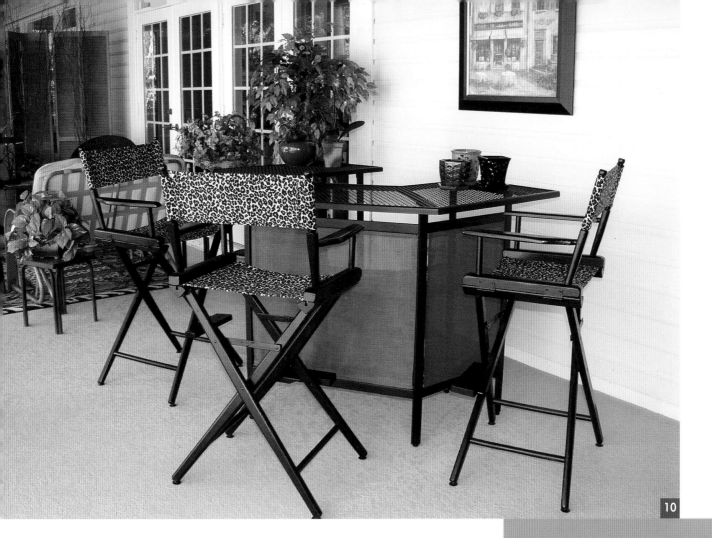

Here's what we did to the bar:

9 Since we chose a brown safari theme and Jennifer already had the leopard director's chair covers, I suggested that both the gray bar and pine bar chairs be painted black. Jen wasn't sure if she wanted to paint the bar at first, simply because she thought it would be too much work. But once the transformation was made, she knew it was the right thing to do. For more substance, a framed picture was brought outside to replace the two terra-cotta wall decorations. Though this picture is not safari in theme, the colors worked well and helped anchor the wall.

10 The leopard print seats on the chairs were tightened to eliminate sag. With a fresh coat of black spray paint on the chairs, the leopard fabric was now connected to the seating area.

Here's what Jennifer said about the transformation:

I had a great time working with Kathy to transform my porch! Truthfully, I was not unhappy with how my porch looked, although my chair cushions were faded and I did want to change them. As soon as Kathy offered her insight on the makeover, I was hooked. Together, we choose a color scheme that continued the colors from the inside out. Kathy's terrific sense of color and her wealth of ideas for paint treatments made for a dramatic transformation. I'm thrilled with my new porch!

Here's what it cost:

$80	**New rug to replace the old turquoise rug**
$35	**Additional slipcover fabric for chair cushions**
$69	**Krylon® Interior/Exterior spray paint for the wicker and director's chairs, louvered closet doors, PVC piping, small center and stacking tables, small lamp, and bar**
$15	**Glass tabletop for center table found in trash**
$18	**6 placemats for dining table**
$20	**PVC piping and rope for plant stands**
$237	**Total Cost** (DOES NOT INCLUDE SALES TAX)

Hot Tub Face-lift

WHITE AND DEEP PINK

A pool or hot tub is a wonderful addition to a home, and if you have a pool patio, it's an easy area to make over. In the next examples, including my own, you'll see how easy it is to go beyond the ordinary and to use your imagination to add color and charm to your poolside space.

I shamefully admit that, like my porch, my backyard pool area had been terribly neglected. What a disaster area! Ugh, or should I say Ugh-ly! My husband and I built our house sixteen years prior to the writing of this book, and boy did it lack color and pizzazz. It was a space that neither of us had time to take advantage of, so it really needed a simple treatment. To create an interesting seating area, I added a few garage sale and thrift-store finds, some plants, and a little bit of paint.

v after

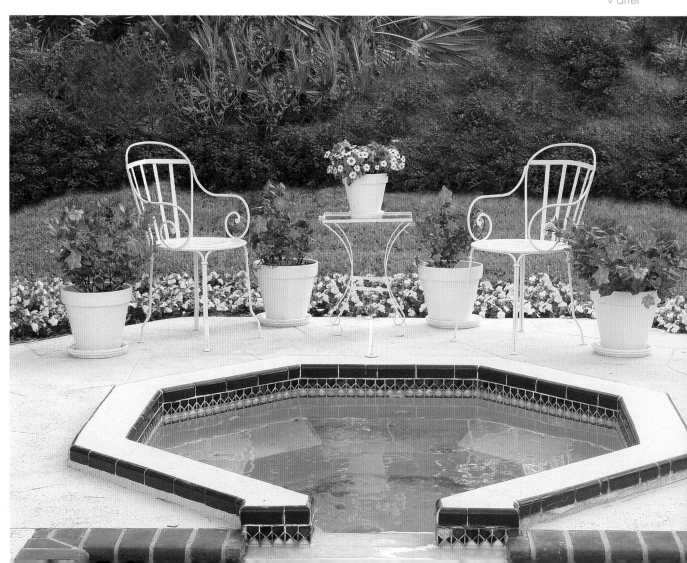

POOLSIDE DREAMING

Here's what I did:

1 I lucked out with the little iron table I picked up at a garage sale and two iron chairs that were freebies from a local thrift store. The furniture was badly in need of paint, so I grabbed my spray paint and was on to my much needed makeover.

2 Two additional terra-cotta pots were purchased and painted white, along with four saucers. Then four new flowering plants were potted to add color. Much needed annuals were planted around the barren edges of the pool patio.

Here's what I said about the transformation:
This space was way overdue for a face-lift and now, after a hard day's work, my husband and I can enjoy the hot tub and also have some additional seating when we entertain outdoors. Amazingly, with a little bit of paint, some new pots and plants, and a few garage sale finds, I was able to create an attractive poolside retreat in just a few short hours for a little more than $100.

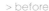

Splashy Retreat

BLUE, SEAFOAM GREEN, DARK VIOLET, AND ARTICHOKE

My friend Betty has a lovely pool area nestled near a winding river. Betty often entertains out-doors, and her pool is the perfect focal point. But it lacked color! As a simple solution, I suggested adding colorful new pillows, potted plants, and a cheerful divider to spice up this pretty pool area.

> before

v after

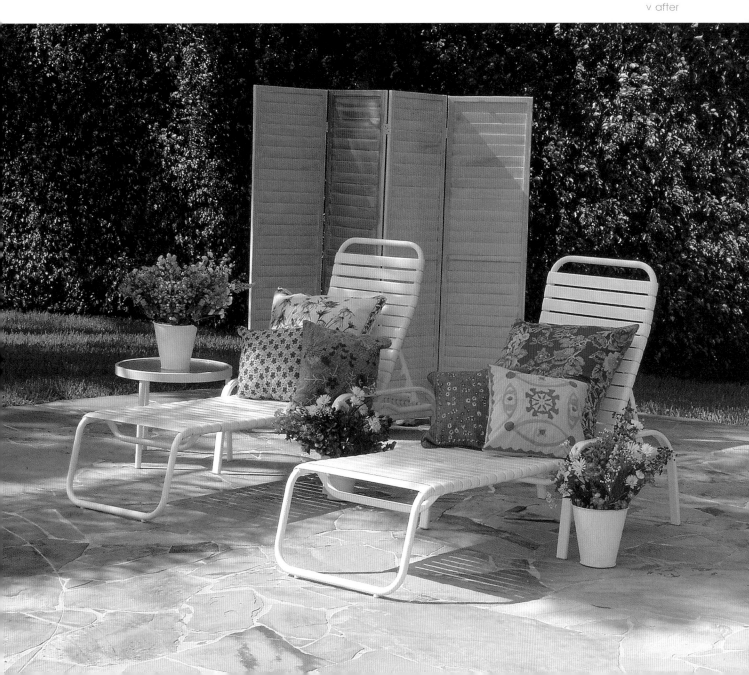

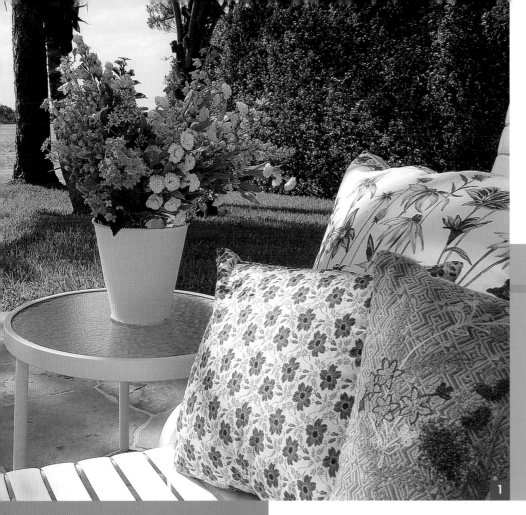

1

DESIGNER TIP

To achieve bright, bold colors, it's best to first paint a surface white. Next apply colored paints over the white background. I wanted to give the room divider an aged and weathered look. To achieve this I added water to a variety of acrylic paints: Delta Ceramcoat Acrylic Paint in Lilac (#2060), Caribbean Blue (#2530), Apple Green (#2065), and Ocean Reef Blue (#2074). I then lightly rubbed the paint on the divider with a rag.

Here's what we did:

1 Bold and bountiful pillows in shades of lavender and blue were added in a variety of sizes. We also added a variety of fresh-cut flowers that matched and complemented the fabric in the pillow covers. When an evening of entertaining is over, the flowers can be brought indoors for more enjoyment.

2 For added interest and to suggest a private lounging area, I painted a four-tier, folding room divider I found at a garage sale in cheerful colors that complemented the pillows.

Here's what Betty said about the transformation:

Wow, it's amazing what a few pillows, some flowers, and a colorful room divider can do to spruce up a couple of poolside lounges. Kathy's sense of color worked perfectly in this location. What a great decorating idea for outdoor entertaining.

2

Balcony Interlude

OLIVE GREEN AND GOLD

Beyond simply being nice places to catch a breeze, the intimate scale of balconies reminds me of romance. Balconies are nice places to enjoy a quiet evening outdoors for a tête-à-tête, cocktails, and perhaps a meal. If your balcony is large enough, you may be able to create separate groups of seating areas for more entertaining options. Mickey's upstairs balcony leads out from her bedroom, and as soon as I saw it I knew it would be an ideal spot for romantic dinners for two. With her lovely antique crystal and dinnerware, she could transform her balcony into an alternative dining spot. By simply moving the antique iron leaf table set and then adding a few potted plants, Mickey and her husband can now enjoy a romantic dinner for two by stepping outside their bedroom.

∧ before

v after

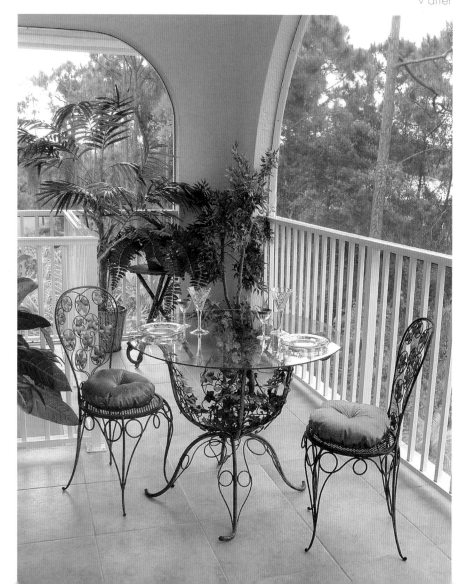

1

Here's what we did:

1 Once the table and chairs were moved away
from the railing, easy access for seating and circu-
lation was obtained. For added comfort and
color, I made round chair cushions for each chair.

DESIGNER TIP

To protect the patina of weathered
metal, seal it with a non-yellowing
lacquer or sealer. This will also
protect fine linens or other fabrics
from rust stains.

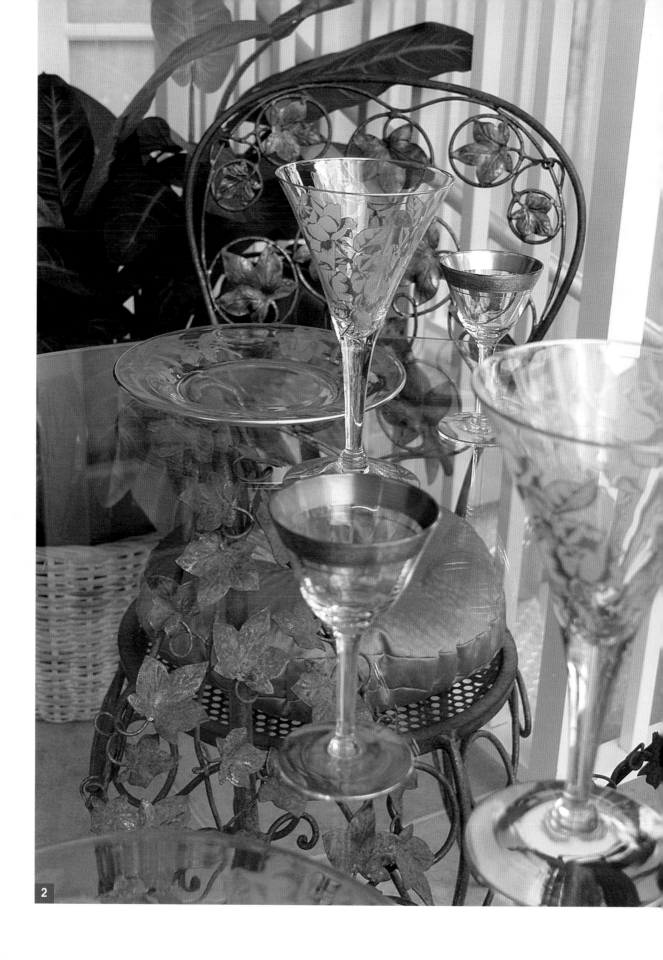

Here's what it cost:

$12	Fabric and Polyfil for 2 round chair cushions
$0	Potted plants for additional privacy and atmosphere
$0	Antique tablewares
$0	Wicker table used as a plant stand
$12	**Total Cost** (DOES NOT INCLUDE SALES TAX)

2 Mickey has tons of wonderful antiques, and I was lucky enough to find the perfect gold-trimmed tableware for an intimate dinner for two.

3 To create more privacy and to soften the porch edges, potted plants and an antique table were nestled in the corner.

Here's what Mickey said about the transformation:

Our bedroom balcony has gone from bland to beautiful. Using a few of my antiques and a little greenery, Kathy has set a beautiful scene for a romantic interlude.

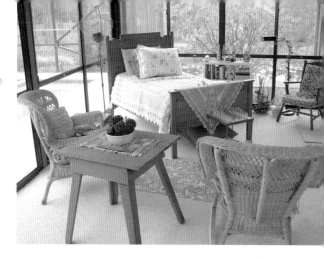

Garden Fresh Sunporch

ROSE, SOFT TEAL, APPLE GREEN, AND WHITE

Though clearly an interior space, sunrooms can offer the best of both worlds. They offer warmth and shelter during cool and rainy, or even snowy, days, yet give the feeling of being in close proximity to nature. I have warm and cheery memories of my grandma's sunroom. It was surrounded by windows and filled with lots of sunshine, and it was one of my favorite places at Grandma's house. If the room is merely screened in, such as the one in this makeover, the sunroom is often referred to as a sunporch. For obvious reasons sunrooms are more functional in northern climates and sunporches in southern ones.

Angela's home is a wonderful mix of eclectic antiques and yard sale finds, and is filled with soft pastel colors. But her sunporch was dull, lacking both a theme

SUNPORCH GLOW

v after

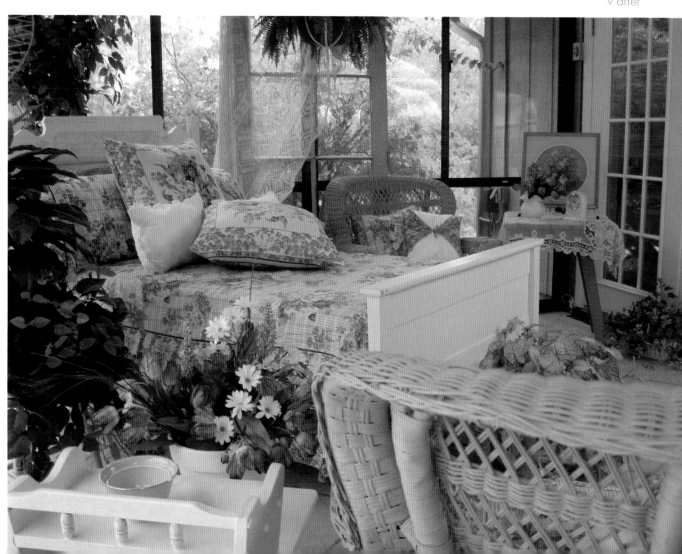

and color. She was using her sunporch as a resting place for her antique bed and wicker chairs, and as a private reading room. When I suggested that we remove the carpet and paint faux tiles on the floor, I had her hooked. I suggested we spray paint the wicker furniture pink and the antique bed white. At first she was a bit squeamish about painting the pine bed, her family heirloom. After the bed was painted, Angela was glad she took my advice. We recruited a couple of construction workers to help us remove the carpeting. Then the two of us tackled painting the floor together. We had a blast creating this restful sanctuary. Now it's a welcoming and restful extension of her home and a cozy space for relaxing, reading, and taking an afternoon nap.

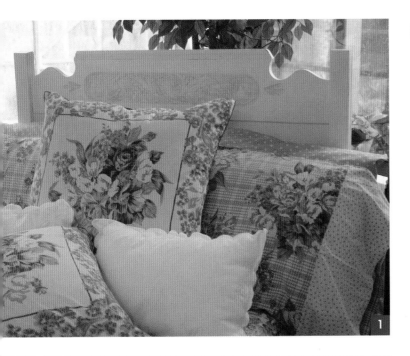

Here's what we did:

1 First the bed was painted white. Then we decided to bring out the carved relief on the bed by mottling it with green paint. This was done by rubbing a little green acrylic paint on the relief and then wiping off the excess to emphasize the raised appearance of the carving. The bed and chairs were accessorized with fresh floral linens. We used a tablecloth for the bedspread, ready-made pillowcases, and a couple of white accent pillows that I made from leftovers in Angela's antique linen stash. I slipped four pillowcases over the existing large pillows, making for an easy transformation. These large pillows had been sorely underutilized. In the "before" shot you can see that Angela simply stored them under the bed!

2 The wicker chairs were in good shape but needed a lift. We rearranged them and gave them a fresh coat of pink spray paint. It was a fast and easy paint application. I used napkins (coordinated with the bedspread that was previously a tablecloth) to make the chair cushion covers and tied a napkin around a white pillow for more interest.

DESIGNER TIP

Though our budget didn't allow it, I would suggest adding sheers for more privacy when guests stay over.

3 Angela has loads of wonderful accessories in her house and outdoor shed. We pulled an old green door from the shed, leaned it against the screened windows, and then hung an antique tablecloth from it to soften the edge. A hanging fern that Angela was using elsewhere was added for more texture.

4 After the carpet was removed, we cleaned the concrete and then taped off sixteen-inch squares on a diagonal. Using a roller brush, Angela applied the green paint while I followed, sponging in white paint to create a mottled, faux-tile look. Once the paint was dry, we removed the tape. For the final touch we handpainted the grout using gray paint and an artist's brush.

5 Remember the green table and the lacey curtain she had previously hung over the footboard of the bed? By simply moving the table to the corner of the porch, covering it with the same curtain, and adding plants and accessories from Angela's home, this outdoor space suddenly opened up.

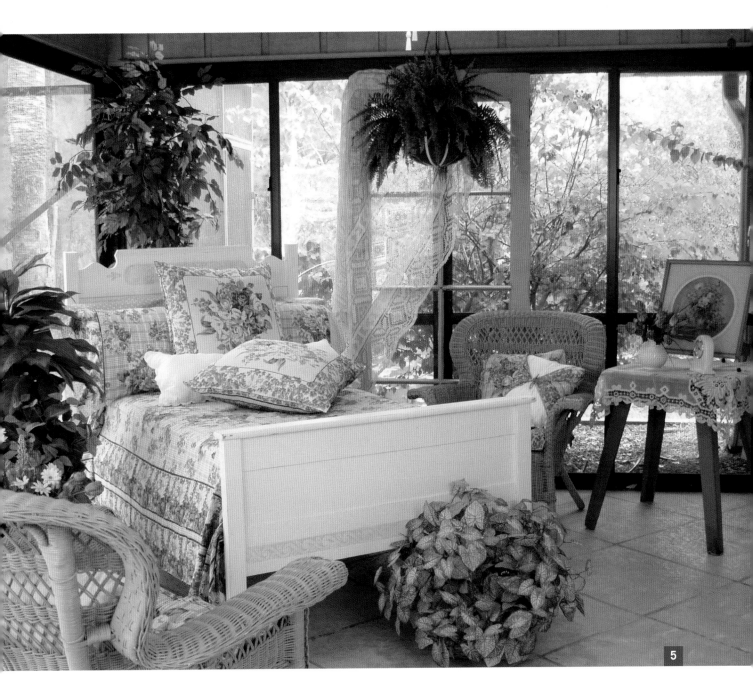

5

Here's what Angela said about the transformation:

After purchasing our home less than a year ago, my husband and I painted the entire interior and added some architectural details to make it our own. We loved it. And then there was the sunporch. We didn't know what to do with it, and therefore we didn't use it. Kathy had some wonderfully creative ideas about how to make the space functional and beautiful. She suggested painting the antique wood furniture white.

At first I had reservations, since it had always been the natural pine finish. Thanks to Kathy's encouragement the furniture turned out perfectly. We also painted the concrete floor with a faux finish, giving it the appearance of real tile. At a nominal cost, and within a short period of time, we created a comfortable sleeping porch and sitting area in a space that had been drab and uninviting. Thanks, Kathy!

> before

Corner Garden Getaway

PINK AND WHITE

If you don't have enough ground to have a garden, then the next best thing is to create a gardenlike setting on your patio, porch, or courtyard. Plantings and flowers can easily transform a neglected outdoor space into an inviting one. I set out to do exactly that with my outdoor corner area, which definitely lacked a sense of design! My goal was to use this space for potting my houseplants. Nestled under a large, shady ficus tree, I knew it had potential. It housed two lonely iron chairs and several neglected orchids. To fix this outdoor decorating challenge, I added a few garage sale and thrift-store finds, some plants, and a little bit of spray paint.

v after

GARDEN OASIS

Here's what I did:

1 To break up the wall of greenery, I hung a flea market window, spray painted the old orchid baskets, and purchased a new orchid. With the addition of the window, the large green hedge suddenly felt more like a wall, giving the sense of added privacy and protection from the elements.

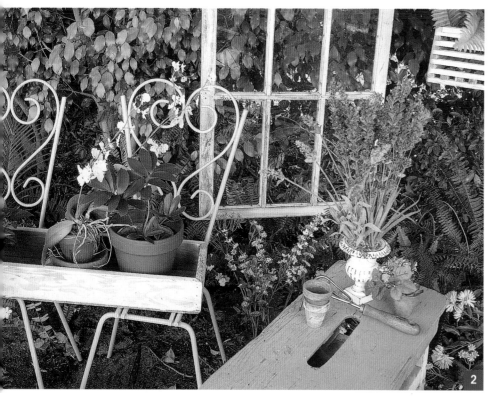

2 My old iron chairs were spray painted pink. Another garage sale find, an old toolbox, was given a light coat of white and pink spray paint for a weathered look and now doubles as a work space for gardening. (Note: To create a painted weathered look, as I did on the old toolbox, lightly spray a coat of paint, allowing the wood to soak up most of the paint.) I placed the inside drawer from the toolbox on the two chairs to create a new plant stand.

3 An old birdbath and chair I purchased at a garage sale, plus an abundance of shade-loving plants, were transplanted from

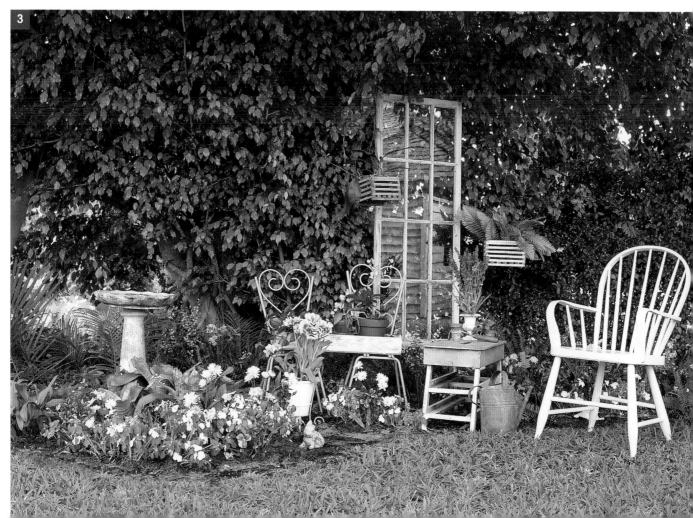

4

Here's what it cost:

$10	Garage sale toolbox used for a small potting table
$.50	Garage sale bunny
$2	Garage sale chair
$20	Garage sale window to transform hedge and add interest
$28	Orchid for color
$0	Transplanted annuals
$0	Pots and saucers for potting plants
$9	Krylon® Interior/Exterior spray paint for the toolbox, orchid basket, and chairs
$69.50	Total Cost
	(DOES NOT INCLUDE SALES TAX)

another part of the yard. I randomly placed the plants to make this space look like a small English garden.

4 Ah, who could resist this little bunny? This garage sale find gives this outdoor space a sense of whimsy.

Here's what I said about the transformation:

What once was an ugly and unsightly outdoor corner now has become an inviting space where I can grab a comfy chair and do some potting and planting or just plain relax. The orchids that were once hidden are now a focal point for this space and are coming back to life. Now I have a little space I can call my own!

Mediterranean-Style Courtyard

COBALT BLUE AND TERRA-COTTA

Courtyards are often associated with privacy, seclusion, intimacy, and lush plantings. Making a stylish courtyard statement to mirror your personality is a great source of inspiration for a beautiful outdoor makeover. The owner of this courtyard really likes color, and knew her courtyard was overdue for a makeover. Since we wanted a big impact we used a bold color combination and fresh plantings, making this courtyard probably the most dramatic makeover in this book. With a bold saturated cobalt blue color and faux-painted terra-cotta tiles, the faded walls and flooring of her courtyard have been transformed into a tranquil Mediterranean escape. Since this courtyard is exposed to the hot Florida sun, this soothing Mediterranean color scheme was a natural choice. Since Lynn could not imagine a blue wall, she was a little reluctant when I suggested the bold colors for her makeover. But in the end she was thrilled with the outcome of her fabulous new courtyard.

v after

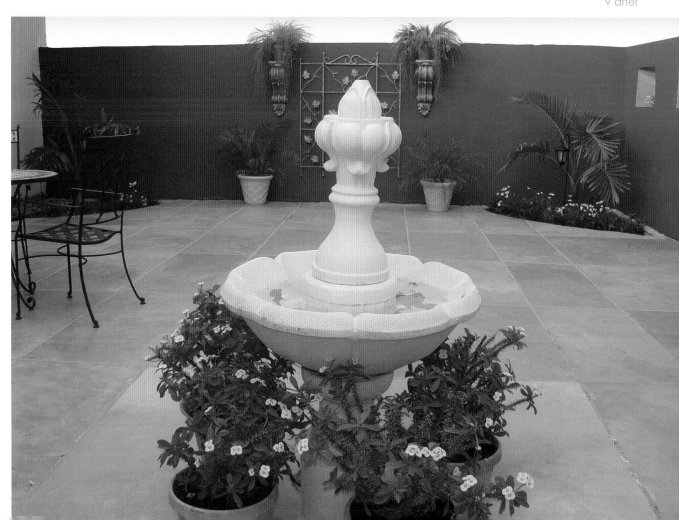

COURTYARD CHIC

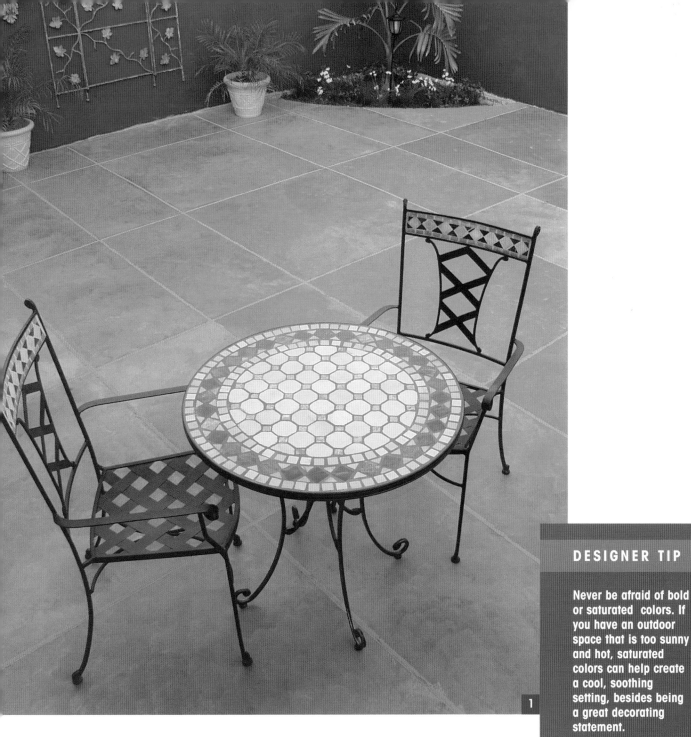

DESIGNER TIP

Never be afraid of bold or saturated colors. If you have an outdoor space that is too sunny and hot, saturated colors can help create a cool, soothing setting, besides being a great decorating statement.

1

Here's what we did:

1 Once all the surfaces had been pressure cleaned and the dying foliage removed, the painting began. First the floor was given a coat of gray primer and taped off. I wanted to reduce the size of the original painted floor tiles Lynn had created years ago. My first suggestion was to paint the tiles on the diagonal, but even after the primer was down, the original painted lines remained visible. So I simply created four narrow rows by taping a grout line down the center of two alternating wide rows. Once the taping was done, we began to paint our faux tiles using dark and light terra-cotta colors, making sure that each tile was mottled differently. Lynn's bistro set looks more inviting sitting on the pretty faux-painted floor.

2 Next the walls were given a face-lift with a dramatic cobalt blue color. New, vibrant plants were added. What a difference!

3 Lynn had tons of potted plants around her home. By using what she already had, painting some of the old pots, and adding a little TLC to her flowering plants, her courtyard suddenly came to life.

4 Lynn already had this soothing fountain. We moved it from its old location in her front yard to the front part of her courtyard, where it helps to obscure an unsightly electrical outlet. The entrance to her courtyard is now visually anchored and welcoming.

5

5 To complement her faux-tile floor we painted two sconces that Lynn had in her house with several colors of craft paint to create a faux terra-cotta look. Filled with hanging plants, the sconces help to create the ambience of a Mediterranean courtyard.

6 Remember the black shelf on the back wall in the "before" shot? Well, it was dismantled, unfolded, painted, and hung in the center of the wall as a focal point. Now Lynn has a place outside to enjoy for herself and to use for entertaining.

Here's what it cost:

$179	**Flowers, pots, and palms to replace the dead plants**
$67	**Exterior paint for the walls and floors**
$0	**Primer for the floor (Lynn already had on hand)**
$0	**Fountain (from Lynn's yard)**
$0	**Painted metal wall decoration (transformed from a shelf Lynn already had on hand)**
$246	**Total Cost** (DOES NOT INCLUDE SALES TAX)

Here's what Lynn said about the transformation:

Kathy, thanks so much for all your great ideas and help on the miraculous transformation of our courtyard. This space was a large, neglected wasteland. I just didn't know what to do with it. When you first gave me your ideas, I must admit that I was a bit skeptical about the blue walls, but the colors really tone down the reflection of the hot sun. It is now part of the living area of our home and sends an inviting message to those who enter our front door. Thank you for turning this space into such a beautiful outdoor oasis.

Flowering Courtyard

LAVENDER, PURPLE, PERIWINKLE, AND LILAC

Julie has lived next door to me for seventeen years and has a charming courtyard. Her husband, Dennis, built the courtyard especially for her and even selected and placed the furniture. It's a lovely space for outdoor dining, but I could immediately see that it had a lot more potential. Her new furniture was a terrific beginning, but the brick seating area had become a resting place for odds and ends of pots and plants. With a few simple furniture rearrangements, and by adding lots of colorful flowers, Julie now has an outdoor space that has come alive with color.

v after

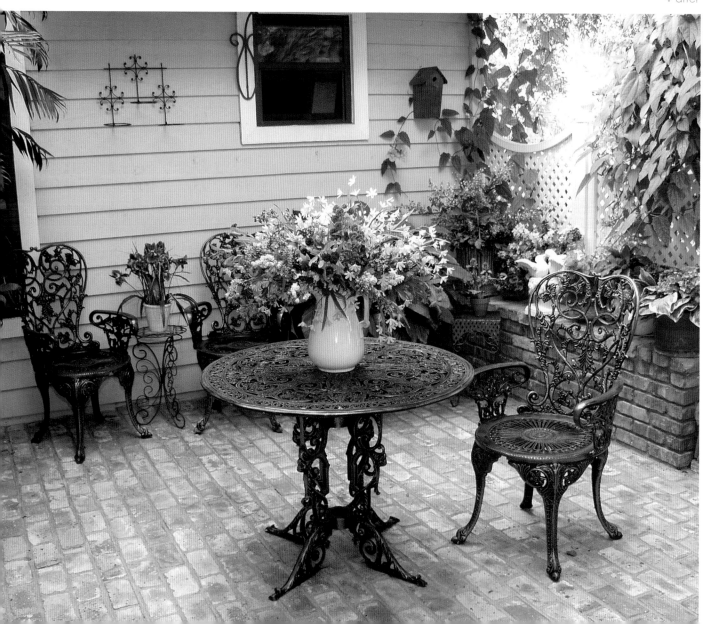

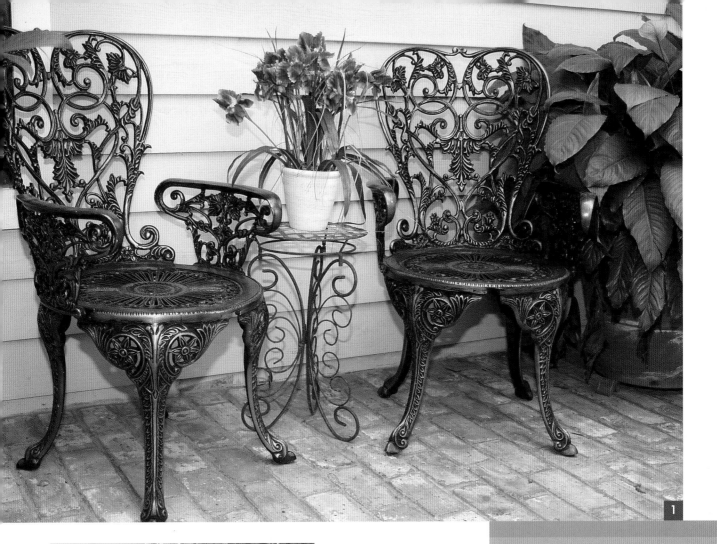

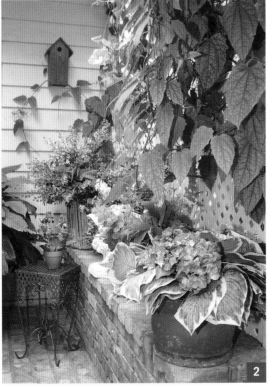

DESIGNER TIP

When you have a small outdoor space and large-scale furniture, try separating and re-grouping the furniture to create multiple conversation areas. It will keep your outdoor space from becoming too heavily weighted in one area and allow for more seating areas.

Here's what we did:

1 First we separated two of the four chairs from the table and grouped them against the house with a small, unnoticed table that had been stuck in the corner of her courtyard. This new seating arrangement lightened the load in the center of the space.

2 To add color, lots of flowering plants were placed along a once neglected brick bench.

121

3 Julie's lovely dove statue adds a point of interest to the bench and is nicely framed by the new plants.

4 A pitcher full of pretty flowers brought in a bit more color and softness.

5 A single chair stayed with the table while the fourth chair was placed on the opposite side of the porch that is not shown. This was a natural choice since the iron furniture, though lovely as a grouping, was too heavy for this small space. Breaking up the set not only lightened the center of the courtyard, but it allowed for more seating areas when Julie entertains.

Here's what Julie said about the transformation:

My courtyard was built for me as a gift from my husband, Dennis, and he even picked out the furniture and put it in place. Kathy has shown me how to transform my patio in a new way. The colors are beautiful, and I think it would be fun to change the flowers to fit each season or event!

Here's what it cost:

$98	Cut flowers and potted plants for color and texture
$98	Total Cost
	(DOES NOT INCLUDE SALES TAX)

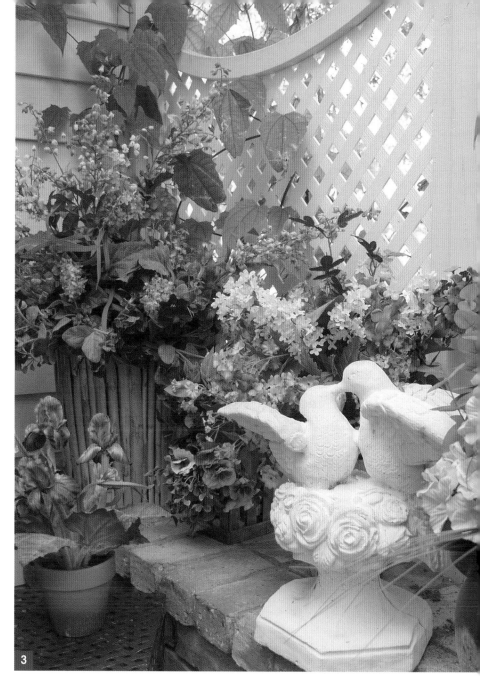

> before

Charming Country Hammock

VIVID PINK, CELERY, AND BLACK

A hammock can offer comfort and relaxation. If your hammock doesn't look inviting, this makeover will give you some simple and colorful solutions for creating a restful hammock for your outdoor space. Laurie lives in the country and has a big yard with a lake. So when I spied her hammock looking lonesome, I came up with a colorful makeover solution. Laurie's hammock was hanging in a very restful spot near a lake bordering her property. To give this hammock even more appeal, I planted a variety of colorful flowers at the base of the pine tree.

v after

The flowers gave me the color inspiration for the pillows and tablecloth that served as comfortable outdoor accessories. Now, as you can see, Laurie has an outdoor space that is not only cheerful, but a great way to relax and enjoy nature.

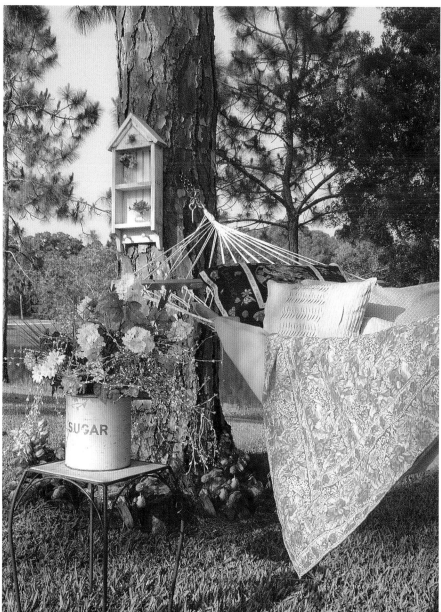

HANDSOME HAMMOCKS

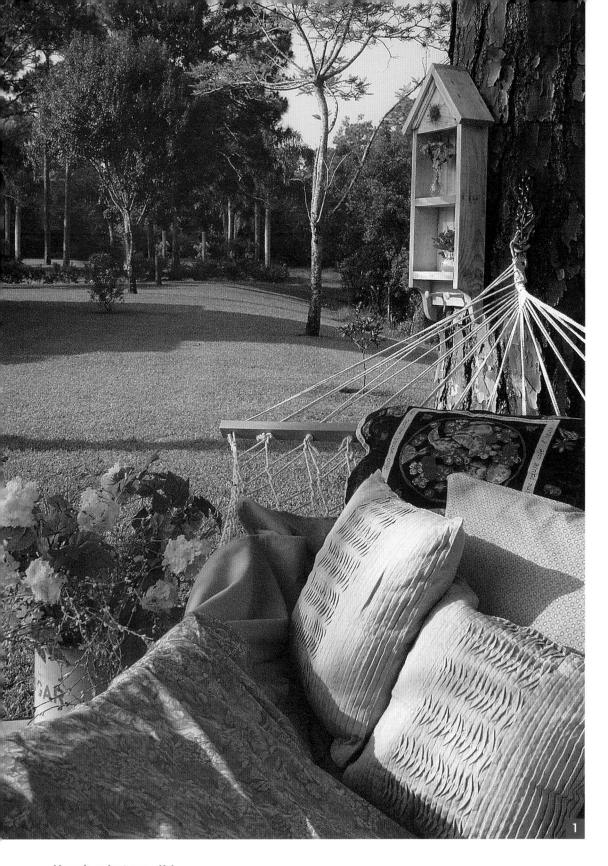

Here's what we did:

1 Pillows, and yes, a couple of tablecloths, set the tone for a perfect resting place.

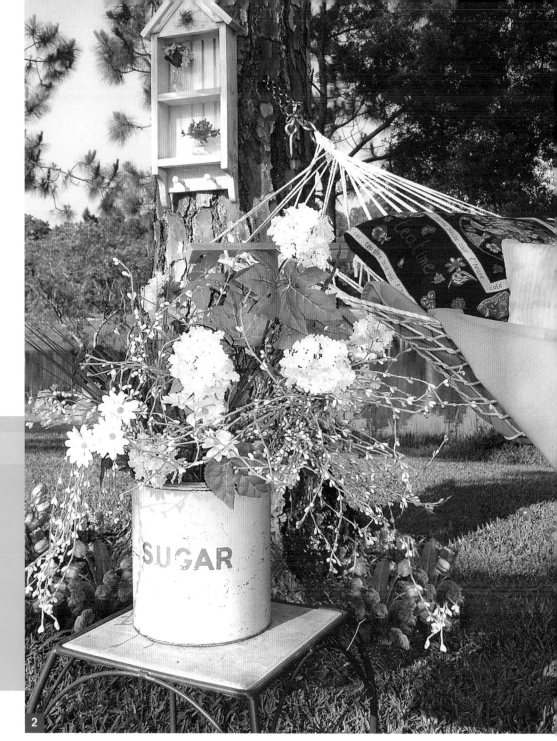

DESIGNER TIP

When you have a wide-open outdoor space and large-scale furniture, try grouping the furniture together to create intimate conversation areas. Use sheets, blankets, or leftover fabrics to add color and pattern to liven up a boring space.

2 To add a touch of whimsy, flowers were potted in a vintage sugar can and a charming birdhouse shelf hung from the tree. Lots of flowering plants were planted at the base of the tree.

3 A couple of Adirondack chairs were brought in from another part of the yard, making this setting a great place for conversation and guests.

Here's what Laurie said about the transformation:
My hammock offers country elegance at its best! The punch of the pink tablecloth in the midst of the green outdoors offer a pleasant surprise. It makes me smile when I look at it.

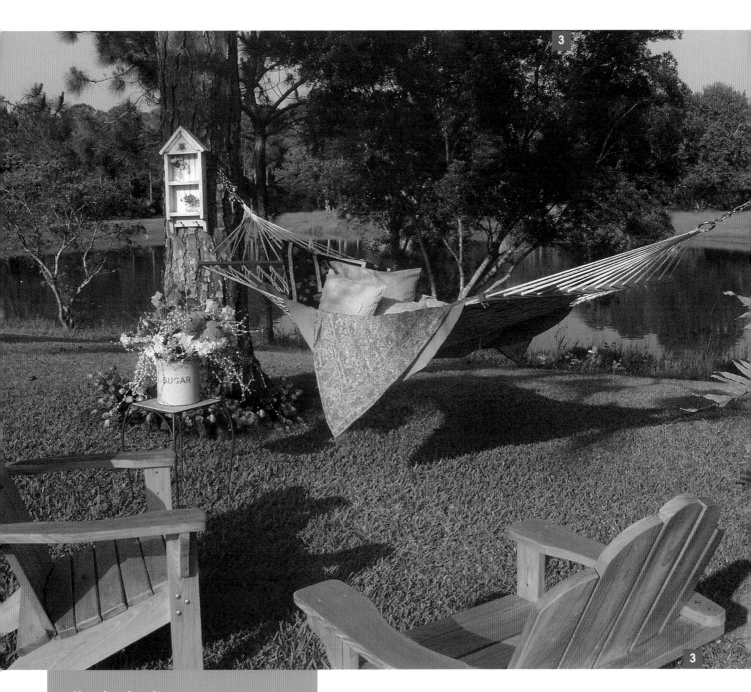

3

3

Here's what it cost:

$56 Planted and potted plants for
 around the tree and for decoration

$39 1 tablecloth for the hammock

$68 4 pillows for the hammock

$25 Birdhouse shelf

$188 Total Cost
 (DOES NOT INCLUDE SALES TAX)

Restful Outdoor Retreat

RED AND WHITE

Angela already had several outdoor vignettes.
The hammock in her front yard was nestled in
a wonderful little nook that Angela had not had
time to tackle. Though lots of colorful flowers
surround her home, her hammock lacked color.

> before

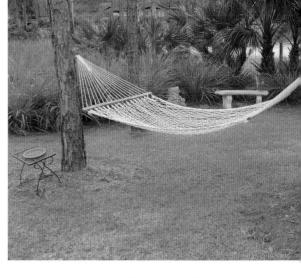

So, by simply adding a few pieces of linen and lace, her hammock is not only
attractive and interesting, but it's also a comfortable little getaway.

v after

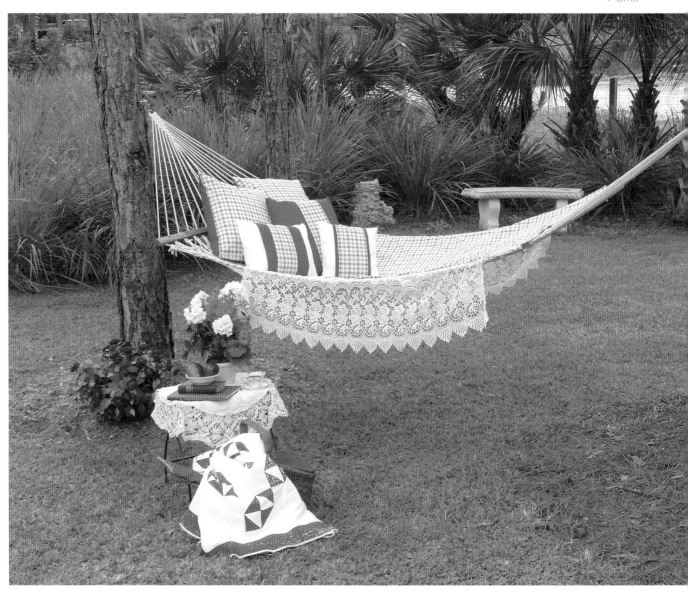

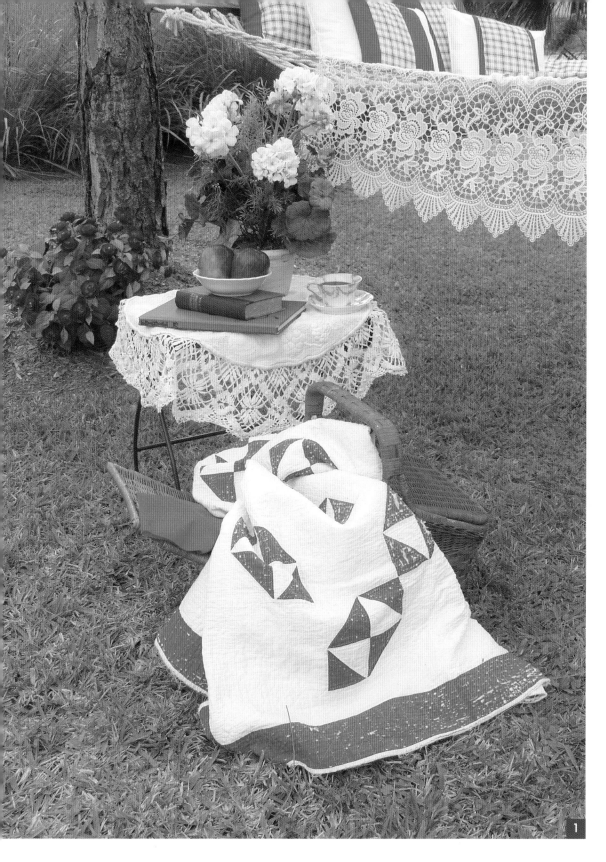

Here's what we did:

1 Vintage lace curtains were draped over the outside edges of the hammock.

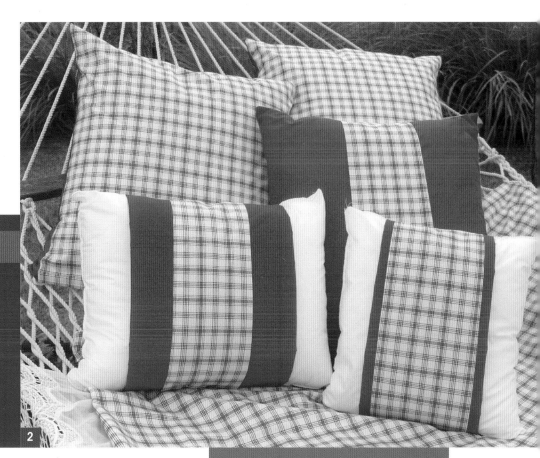

DESIGNER TIP

Ready-made lace hammocks are available for year-round outdoor use, but can be pricey. For a fraction of the cost of a new hammock, the same effect can be created with a little creativity.

2

2 Next a twin sheet was cut in half lengthwise and hemmed. This was placed on the surface of the hammock for added comfort. Coordinated pillows made from the other half of the sheet were combined with solid red fabric.

3 The small iron table was moved forward and covered with a vintage doily. Flowers, fresh fruit, and accessories were added to reflect the colors in the linen cloth.

Here's what Angela said about the transformation:
Kathy took our neglected hammock and shook off the pine needles. With a few comfy, colorful pillows and accessories from my house, she created a beautiful outdoor living space that just invites you to come out and curl up with a book.

Here's what it cost:

$25	5 pillowcases for pillows on the hammock
$5	1 twin sheet for the hammock
$15	Plants and pots for curb appeal
$45	**Total Cost** (DOES NOT INCLUDE SALES TAX)

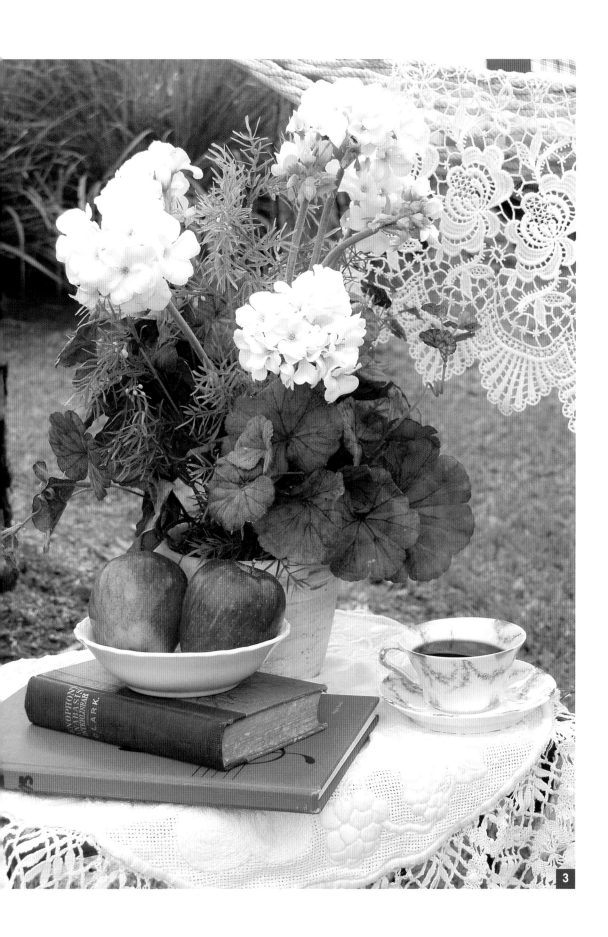

> before

Cabana-Style Swing Makeover

PURPLE, PALE YELLOW, ARTICHOKE, AND WHITE

I love a front-porch swing and have always wanted one. When I moved away from home to go to college, I lived on a street of old Victorian homes with a swing or glider on almost every porch. To this day swinging or rocking reminds me of sunny weekend afternoons, a good book, and whiling away the hours. This home owner's side-porch swing had been hung where the summer breezes could be enjoyed, so to give this space a bit more charm and loads of color I decided to create a beachlike cabana feeling. The morning I came over to Laurie's porch she was busy getting her kids off to school and herself to work. My goal was to surprise her with a completed makeover by the time she was ready to leave for work. What was once an ordinary porch swing is now a colorful, breezy seating area that Laurie and her family can enjoy.

v after

SWING INTO ACTION

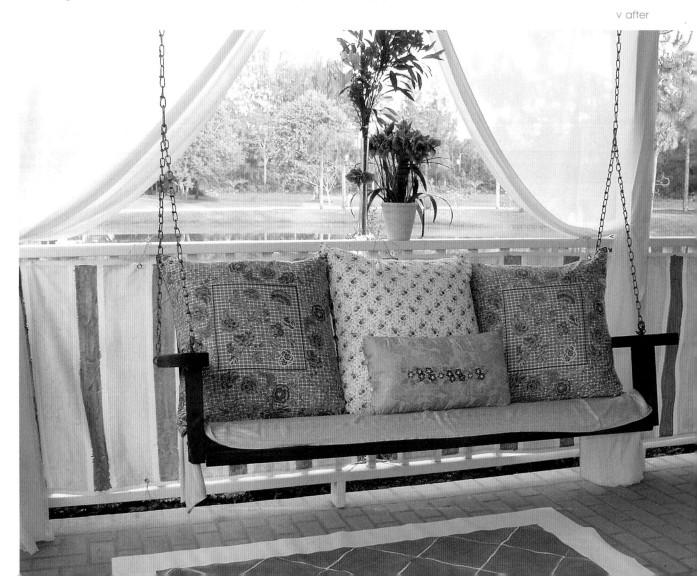

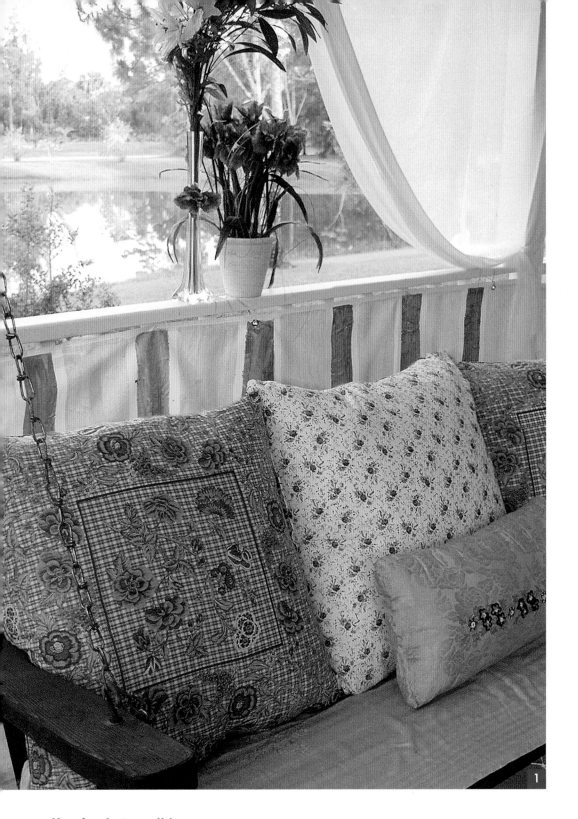

Here's what we did:

1 You can find color inspiration almost anywhere if you know where to look. I was inspired by the colors in these pretty blue pillows, an old shawl, and a couple of sheers hanging from the eves of the porch, all of which helps to create a fresh clean look. The blue reflected the colors of Laurie's kitchen and den, and added even more color. I handpainted simple stripes in blue, chartreuse, and white onto a banner cloth, and then attached the banner to the railing.

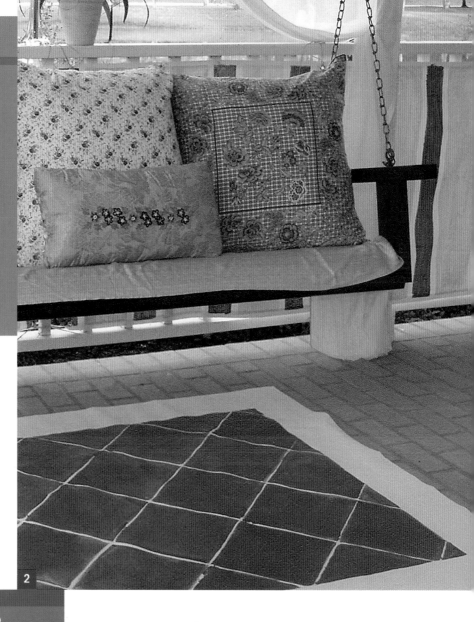

2 To anchor and frame the swing, I handpainted a floor-cloth in cobalt blue and placed flowers on the railing.

2

DESIGNER TIP

Use your imagination and think outside the box. With a little paint and banner or sign cloth, you can create a sense of enclosure. The pretty blue floorcloth also helps make this space more inviting.

Here's what Laurie said about the transformation:
My swing became a cozy country oasis. Kathy managed to bring the inside out, transforming what was a basic uninspiring porch swing into a special private corner in my world.

> before

Inviting and Relaxing Glider

WHITE, PINK, AND LAVENDER

Susie's delightful makeover was inspired by her already bright use of color in her home, which is full of cheerful yellow colors on the inside and is vividly pink on the outside. Her glider and the area around it were the only outdoor space that had been neglected. When I suggested to Susie that we change the color of her glider to white, she wasn't sure if that's what she wanted to do. She felt that since it was an expensive piece of wood furniture, she should leave it natural. But with a little pep talk, I suggested that if we stained her glider white, it would be more inviting and mix well with her pink home.

Once I convinced Susie that white would make the glider more inviting, she agreed and we tackled the project together. With a few added pillows and freshly planted flowers, Susie now has a comfy space where she can enjoy the outdoors. And what was once a drab and uninviting outdoor space now beams with color.

v after

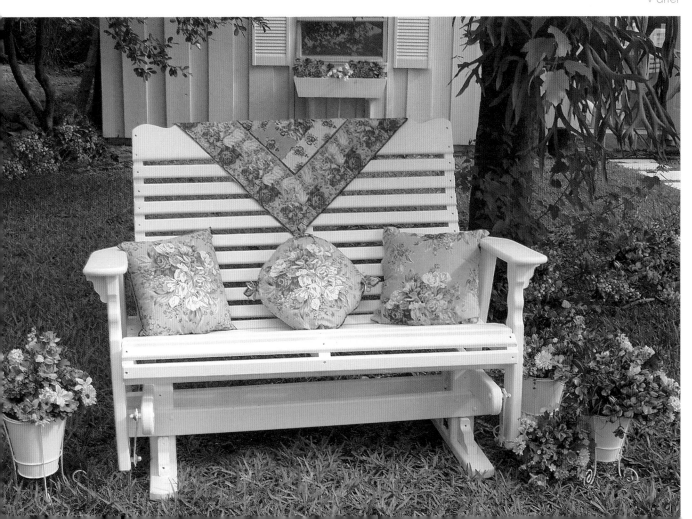

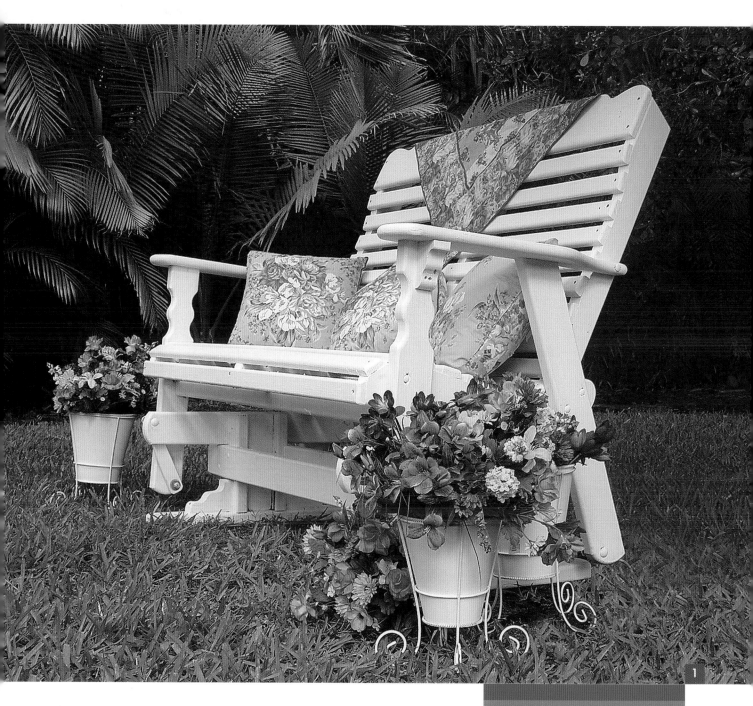

DESIGNER TIP

When adding color to outdoor wood furniture, use stain instead of paint to prevent peeling. To save cost, use pillows you already have from inside your home.

Here's what we did:

1 First the glider was cleaned and dried thoroughly. Then we stained the wood white using leftover white stain Suzie had from a previous project. We used solid stain to hide the natural wood grain. (Note: If you prefer to see the natural grain of wood, then I suggest using a semitransparent stain.) Within just a few hours, and with a few added pillows and some potted plants, Susie now has a charming glider that had come back to life.

2 To further brighten up the glider, I placed a large, colorful pillowcase on point over the back. The pillowcase complements the pink guest house and creates an inviting seating area for Susie's guests.

3 Colorful pillows add charm and comfort to Susie's glider.

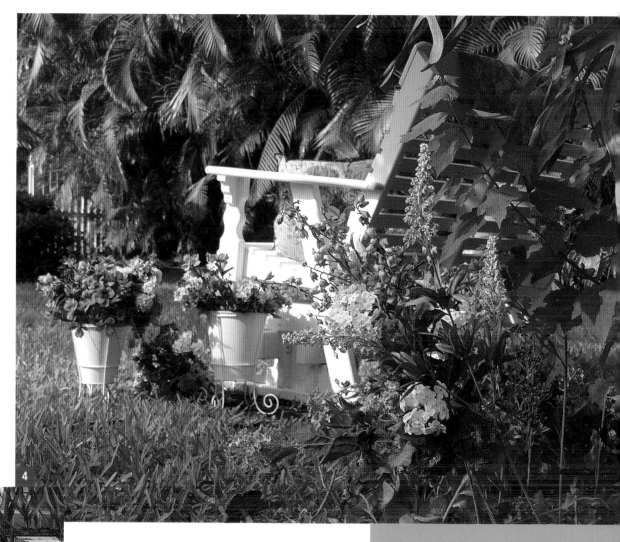

4 Pretty perennials were planted around the base of the tree, and potted plants added a special touch.

Here's what Susie said about the transformation:

It's amazing what a little stain and flowers can do. Before, no one even noticed my glider under the big maple tree, but now it's the perfect spot to sit and relax in the Florida sun. And the colors make it so inviting! The stain made the glider pop, and the fabric looks great with all the colorful flowers. Thanks a bunch!

Here's what it cost:

$76	4 pillow covers and pillow forms for the glider
$0	Stain for the glider
$51	3 pots with stands for flowers
$25	Perennials and plants for planting pots
$152	**Total Cost** (DOES NOT INCLUDE SALES TAX)

ACKNOWLEDGMENTS

Making over the many porches, patios, and other outdoor spaces during a period of six months, coupled with the many photo shoots, prop and supply gathering, treasure hunting, and setups, could not have been completed without the contributions and hard work of my old and new friends. Many thanks go to Cornell Trading and Robin Gronlund for supplying me with the lovely and colorful linens that make many of the porches in this book blossom with color. Allison Vinciquerra of Bella Lingua Public Relations, Ltd., representing the Krylon® Products Group, was always there for my last-minute spray-painting needs, as was Kenneth Becker of SafeWorld International for the Can-Gun® handles that make spray painting so easy. Karla Neely, representing Thompson's® Water Seal® Products, was a great help. Thanks also go to Pamela Smart, a representative of Fredrix® Canvas and Taracoth®, for supplying me with artist's canvas, banner cloth, and floorcloths. I also thank Fleeta Jennings of DCC (Decorator and Craft Corporation) for many of the lovely white iron and metal accessories, and Tracy Whitlock at Fairfield Processing for all the pillow forms. Thanks go to my photographer and friend, Chris Lincoln for all the extra-early morning photo sessions. Even more thanks go to my neighbors, family, and old and newfound friends for trusting my outdoor decorating suggestions. And, as always, I appreciate my editor and friend Joy Aquilino for believing in my work, and project editor Holly Jennings for making this book come together.

RESOURCES

ARTIST'S CANVAS AND BANNER CLOTH

Fredrix® Canvas Taracloth®
 All Weather Sign Cloth
Tara Materials, Inc.
111 Fredrix Alley
Lawrenceville, GA 30046
770-963-5256
fax: 770-963-1044
www.taramaterials.com

CRAFT PAINTS

Delta Technical Coating
2550 Pellissier Place
Whittier, CA 90601-1505
800-423-4135
www.deltacrafts.com

SPRAY PAINTS AND SUPPLIES

Krylon® Product Group
800-4-Krylon
www.krylon.com

**The Original Can-Gun®
SafeWorld International, Inc.**
P.O. Box 1030
Ashland, OR 97520-0049
800-743-0115
www.safeworld.com

STAINS AND WATER SEALERS

Thompson® Water Seal® Products
For questions and information call
800-367-6297
www.thompsononline.com

CANDLES

Hanna Candles
800-327-9826
www.hannacandles.com

ACCESSORIES

DCC
800-835-3013
www.dcccrafts.com

TABLE AND BED LINENS

Cornell Trading
www.AprilCornell.com

PILLOW FORMS

Fairfield Processing
P.O. Box 1130
Danbury, CT 06813
www.poly-fil.com

THE AUTHOR

Kathy Peterson
www.kathypeterson.com

INDEX

PHOTO CREDITS

Thompson's® Water Seal®
Clear Wood Protector: p. 47;
Thompson's® Water Seal®
Advanced Wood Protectors:
p. 14 (middle), p. 30 (bottom),
p. 31 (top and bottom), p. 45;
Thompson's® Water Seal™
Deck & House Latex Stain:
p. 20 (left and right), p. 32
(top). All other photographs
are by Christopher
Lincoln/Lincoln Productions.

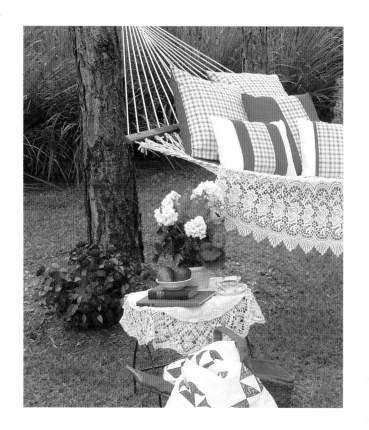